SECRET PENRITH

Andrew Graham Stables

AMBERLEY

First published 2016

Amberley Publishing
The Hill, Stroud
Gloucestershire, GL5 4EP

www.amberley-books.com

Copyright © Andrew Graham Stables, 2016

The right of Andrew Graham Stables to be identified
as the Author of this work has been asserted in
accordance with the Copyrights, Designs and Patents
Act 1988.

ISBN 978 1 4456 5381 5 (print)
ISBN 978 1 4456 5382 2 (ebook)

British Library Cataloguing in Publication Data.
A catalogue record for this book is available from the
British Library.

Typesetting by Amberley Publishing.
Printed in Great Britain.

Contents

Introduction

Penrith is located to the west of the northern Pennines, in the county of Cumbria, at the meeting of north–south and east–west routeways. The town is surrounded by a plethora of evidence of ancient British and Roman occupation, but the actual market town was probably developed during the twelfth century. The building of the castle only began in 1397 following several destructive Scottish raids in the fourteenth century. Yet the area around St Andrew's Church at the centre of the town must have served some purpose during the Anglo-Saxon and Viking age. The churchyard contains an ancient sculpture known as the 'Giant's Grave' and though the current church dates from 1720, the abutting redsandstone tower is from the twelfth and thirteenth centuries. There is growing circumstantial evidence of pre-Norman settlement in the area around the church based on the layout and Old English town name.

The town's strategic position was important to both Scotland and England. These two nations have exchanged ownership of the town several times and suffered from numerous raids, as well as conflict, over the years. The 'Scottish Wars' and border raids were curtailed following the accession of King James VI of Scotland who became King James I of England in 1603, though within a few years his son, Charles I, plunged the country into further hardship during the English Civil War, and Penrith would not escape this brutal struggle between King and Parliament. In 1648, one of Cromwell's most able generals, John Lambert, was based at the castle before the battle of Preston and was probably responsible for damaging its ability to be used for defence.

Even later during the Second World War, it is not fully appreciated the importance Penrith and the area around the town played in the invasion of Europe. Many of the surrounding stately homes and their land were used for secret tank development, manoeuvres and training in preparation for Operation Overlord in June 1944, also known as D-Day.

Education also played an important part in the history of Penrith with the Bishop of Carlisle founding a 'Grammar' school as early as 1340 and this being continued by patronage from Queen Elizabeth I. In 1661 a school was founded for the education of poor girls and did so for over 350 years before closing in 1971. During the 1770s William Wordsworth and his sister Dorothy attended a school in Penrith, and it was here that he met Mary Hutchinson, who was to become his wife.

Penrith is now the administrative centre for the Eden Valley but has always been important due to its position in the landscape and because of cattle droving, the woollen industry, agriculture and coal. From the nineteenth century its position so close to 'picturesque scenery' made it an increasingly fashionable resort and an attraction for some of our finest artists including J. W. M. Turner. The population grew from around 4,000 in 1801 to around 9,000 by the end of the century (in part due to the rail expansion in the mid-1800s) and currently stands at approximately 15,000.

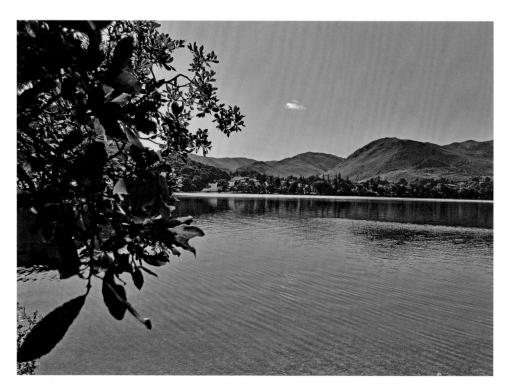

Ullswater is one of the most beautiful and largest lakes in the Lake District National Park.

Having grown up in Barnard Castle, further along the A66 towards Scotch Corner, I have always been fascinated by the rich history of this region and hope to highlight some of the lesser-known aspects of the town. Penrith and Barnard Castle are also linked by one of the most notorious kings in our history, as both were under Richard III's ownership before his demise. Penrith may appear to be just a town you drive past on the way to the Lake District National Park, or zoom past on your way to Scotland, but in reality it holds a wealth of interesting historical stories. I hope you find this book useful in your exploration of this area.

DID YOU KNOW THAT...?

The earliest reference to Penrith is contained within the pipe rolls of 1167. Penrith is called 'Penred Regis' and it is believed to be a Royal Demesne.

1. The Centre of Vital Routeways

Penrith has been at the conjunction of routeways north and south, as well as east to west throughout the ages. There is major evidence of ancient man spending vast amounts of time here to erect stones, build monuments and modify the environment around them. Whatever these monuments were used for is likely to remain a secret lost in time and perhaps we will never know whether they were for tribal leaders' meetings or for ceremonial and religious purposes, but clearly supreme effort was required by the local population to build them.

To the north-east sits 'Long Meg and her Daughters' and 'Little Meg' stone circles; to the south is 'Mayburgh Henge' and 'King Arthur's Round Table both earthen mounds. With other standing stones, stone circles and cairns located to the south-east, south-west and north-east, this amount of pre-Roman evidence suggests an established, complex and numerous populous.

However, Roman evidence in Penrith itself is limited and they seem to have skirted the area where the town now sits. This suggests Penrith did not exist until much later as the forts were situated at Brougham (*Brocavum*), Old Penrith near Plumpton (*Voreda*) and Troutbeck. The roads connected between these forts, from Brougham north through Old Penrith to Carlisle and from Old Penrith south-west towards Troutbeck and continuing

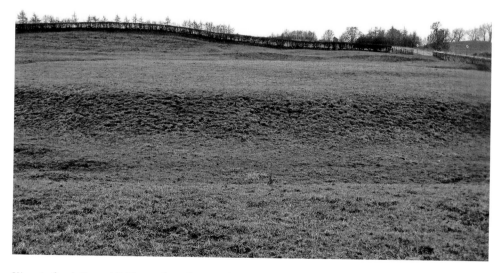

King Arthur's Round Table earthwork at Eamont Bridge.

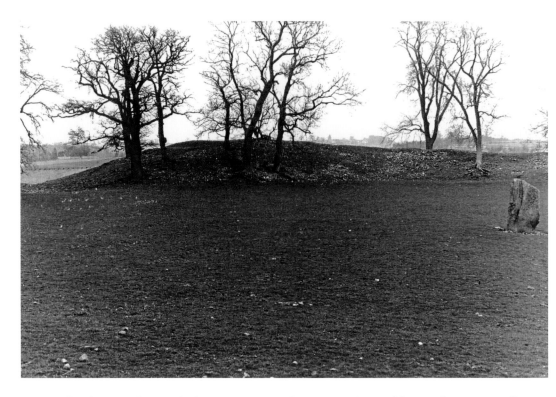

Mayburgh Henge showing the last remaining standing stone and part of the raised ring. Unusually the circle is built from piled–up river stones. (Photo courtesy of the Parkin Raine Collection)

along to Maryport on the coast. Another Roman road headed off over the hills towards Ambleside and is known as High Street – a popular route for walkers. The fort at Plumpton (*Voreda*) is also known as Old Penrith and inscriptions found on stones recovered from the site tell of a cohort of Gauls, from the Gallic tribes of central and northern France, who were stationed here between AD 178 and AD 249.

The Roman road north from Brougham to Carlisle runs beneath the Penrith suburbs of Carleton, Scaws and Fair Hill, but these are suburban expansions built onto old farm or estate lands aren't they? There is actually evidence for Roman structures along this road expanding out from the fort, and this extension to a fort is known as a *vicus*. A *vicus* usually consists of shops, bath houses, workshops, family homes, inns and brothels, or everything you would need to support a barracks. Items found on the site, during the digging of a sewerage main, included jewellery, gaming counters and drinking vessels. Long days protecting the border regions of the empire would always include women, gambling and drinking; it seems things changed little over the years.

There is also evidence of defences around the town by way of dykes and mounds but until excavated exact dates are unknown. Off Oak Road, opposite Brent Road, a raised mound is visible, and Bell (2012) maintains this is a complete 40m × 26m platform of the Roman town's northern gateway.

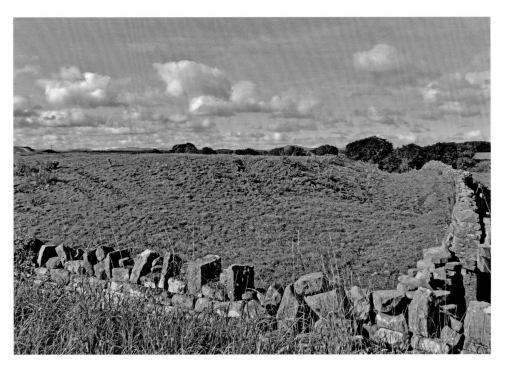

Voreda (Old Penrith) is the Roman fort at Plumpton north of Penrith on the A6 road.

The raised rectangular platform of Voreda is clearly visible here.

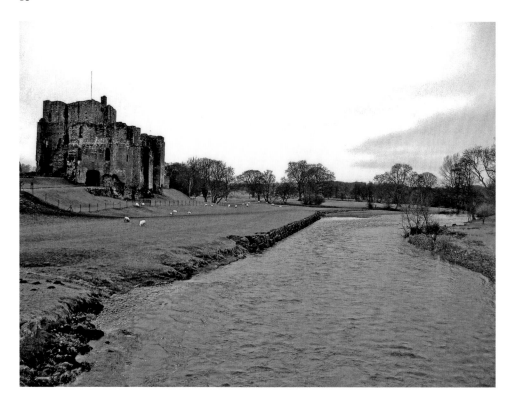

Brougham Castle by the River Eamont south of Penrith.

Though the name Penrith is believed to be derived from the Celtic word *pen,* meaning hill, and *rhudd,* meaning red, the area is also influenced by the people who followed the Celts and Romans. The pattern of small farms and drystone wall division of land originates from Norse tradition. The Vikings also left behind much of their language in place names ending in 'by' or 'thorpe'. Streams are called 'becks', from the Norse *bekr,* waterfalls are 'forces' from the Norse *foss,* and 'fell' derives from *fjall,* the Norse word for mountain. Other words familiar to the area include *wath,* meaning ford, or *thwaite,* a clearing, and *how,* translated as a hill. The Viking influence is still strong in the Lake District and a Norse-English mixture of languages continued to be spoken there until at least the twelfth century.

Whereas most market towns are situated by a river or grew up around a local castle, Penrith fits into neither of these scenarios. Though there is a castle, this was built after the town obtained its charter for a market and the main rivers, the Eamont and Eden, flow to the south of the town. The main freshwater source for the town comes from Thacka Beck, a stream originally diverted by the bishop of Carlisle to supply the town and this waterway is now almost completely hidden within culverts built as the town developed. It must therefore be reasoned that the main reason Penrith exists is due to its location at a vital crossroads, becoming an post for the region.

Clark's Survey of the Lakes 1787 said,

Penrith is, perhaps, the greatest thoroughfare in the North of England. The Irish now cross the sea at Port Patrick, and consequently take this way to the metropolis; shuld they come by Whitehaven this is still their road; besides, since the recent improvements, those who are travelling from Scotland to London generally chuse this road. Another set of never failing travellers are those whom nature, in opposition to an absurd law, prompts to connubial ties; this way they must come to Gretna Green; more famous, though less dangerous, in our days, than the promontory of Leucothoe was in days of yore. Those, likewise, whom a taste for natural beauties impels to visit the Lakes, always consider Penrith as a kind of home in those solitary regions; and the consequence is natural; all the inns here seem to vie with each other in attention, and strain every sinew in making the country as agreeable as possible.

Even today the region is criss-crossed by vital transport links such as the A66 road, running east–west, the A6 running north–south and the M6 motorway opened to the public in 1971. Though some of the rail links have been severed over the years, the town still maintains a station and is sat on the vital West Coast Main Line from south to north. Penrith is also at the centre or starting point for some spectacular and challenging cycle routes.

DID YOU KNOW THAT...?

During the Norman period, Penrith stood in the designated area known as the Forest of Inglewood. This did not necessarily mean a heavily wooded area, but meant that it became a Royal Forest, or a large tract of land set aside for hunting with special laws to protect the local Lords' rights. Inglewood is thought to mean the 'Wood of the Angles' and the forest covered a huge expanse of land between Carlisle and Penrith.

2. The Conflicts

The Borders, Penrith and the surrounding areas have been fought over by different factions, powerful lords, as well as the kings of Scotland and England for centuries. The area has changed hands many times, the border between England and Scotland redrawn, and the town's strategic position used by opposing forces on many occasions. The first known occupants of what is now roughly Cumbria was the Carvetii tribe and we are only aware of them due to a couple of inscriptions on Roman stonework. The rest of the north of England was occupied by a tribe called the Brigantes whose queen, Cartimandua, maintained a treaty with the invading Romans. It was not until she divorced her husband Venutius (who may have been a Carvetii) and he rebelled against her, as well as the Romans, that the accord between these tribes and the Romans was tested. With ruthless efficiency the Roman war machine suppressed the rebellion and resolved to conquer the north. From AD 79, during the governorship of Gnaeus Julius Agricola, the Romans swept north from Chester and York, and west via the Stainmore pass. Little is known about the part the Carvetii played in this conflict, but it must be assumed they fought with the Brigantes to repel the invaders because the Romans built a series of forts to protect this land and to guard the roads.

The Romans exerted their power over the region for the next 330 years and evidence of their occupation can still be seen in the walls, forts and earthworks they built. It is generally accepted the Romans left Britain in AD 410 after Emperor Honorius recalled the legions and told the remaining Romano-British population to fend for themselves. The decline of Roman Britain was not instant as is generally depicted, but would have been a gradual process as areas became small sub-kingdoms defending themselves against invasions of Angles, Saxons and Jutes. It is also known that the Romans used some of these Germanic tribes as mercenaries and some were already located in Britain. They must have liked what they saw and knowing the country was undefended they could invade with some confidence of being victorious.

The area around Penrith became known as 'Rheged' though in its entirety it covered most of Cumbia, parts of Yorkshire and parts of Lancashire. There were heroic attempts by King Urien Rheged and his sons to hold back the invading hordes but the area around Penrith was eventually conquered by the Angles based in Northumbria in around AD 600. Later, from around AD 800, there was further settlement by Vikings from Ireland, as well as hostile invasion by Danish Vikings. At this time Cumbria and south-western Scotland were known as the Kingdom of Strathclyde.

In AD 927, the Anglo-Saxon Chronicle tells of a meeting of five kings which took place at Eamont Bridge just outside Penrith, with the King of Strathclyde and Cumbria, King of Scotland, King of Wales, King of Northumbria and Aethelstan the King of Wessex who was to be their overlord. This is generally seen as the date of the foundation of the

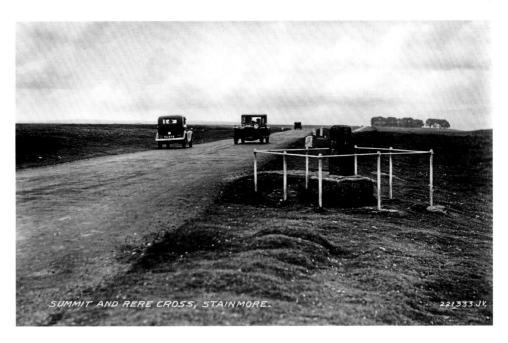

SUMMIT AND RERE CROSS, STAINMORE. 221333 JK

Rey or Rere Cross on the Stainmore Pass, but is it a border or burial marker? (Photo courtesy of the Parkin Raine Collection)

Kingdom of England of which Penrith was a part. Owain Caesarius, King of Cumbria from AD 920 to AD 937, is believed to be buried at Penrith in the 'Giant's Grave' next to St Andrew's Church, but more about this later. In AD 945 the last king of Cumbria, King Dunmail, was defeated in battle at Dunmail Raise, near Grasmere, and Cumbria was granted to one of his sons, Malcolm I of Scotland.

The kingdom of Strathclyde stretched from Glasgow down to north Lancashire, bordered Northumbria and was supposedly marked on the Stainmore Pass by an ancient cross still visible on the A66 known as Rey Cross. An alternative theory to the border marker is, the cross dates from the mid-tenth century and is where the Viking king known as Eric Bloodaxe was killed and buried on Stainmore.

From 1066 the south of the country was taken over by the invading Normans and they began to bring the whole country under control. The period 1069–70 has become known as the 'Harrying of the North' but in reality this was a time when various factions were vying for power in the north. This involved a king of Denmark, local Anglo-Saxon forces and Malcolm III, King of Scotland. Following various attacks and counter-attacks by the Normans and Malcolm III during this time, the evidence is that Cumberland was still in the hands of the Scots. This is probably because it was considered to be Scottish territory and not part of the invading Norman remit. The Domesday Book, produced in 1086, does not include the lands now called Cumbria and it is believed the reason for this is that they were not under Norman control. However, after another Scottish incursion into England in 1092, King William II (the son of William the Conqueror) travelled north determined to end the Scottish threat by capturing Carlisle Castle. Cumbria was incorporated into England, but the kingdom of Strathclyde was not and opened up Cumbria for settlement by Norman nobles.

Around 1130, Cumbria was granted back to Scotland by English King Henry I, and it is believed in 1133 St Andrew's Church was established in Penrith. There is no substantial evidence of Penrith existing before the twelfth century apart from the pre-Norman place names, and a possible town centre layout suggestive of earlier occupation. The earliest mention is a Pipe Roll of 1167 under the pleas of Alan de Nevill of the Forest of Inglewood for 'Penred Regis' (King's Penrith). The original brass 'Penreth Town Seal', dating to the twelfth century, is displayed in the town museum and contains a saltire-like symbol. In 1223 Penrith was granted the right to hold a market, which implies an established settlement. The ownership of Penrith was still disputed in the 1200s though the town was a royal manor under Henry III of England until 1242, but Cumberland and Westmoreland was still claimed by the Scots. In 1242, Penrith, along with a number of other manors, was given to the Scots as a tenancy in order to pacify the tensions in this border area. These tensions give rise to fortified buildings and probably the oldest standing building in Penrith today is the Hutton Hall Pele Tower thought to date to around 1272.

In Brougham to the south, the medieval castle is built on the same site as the Roman fort by the Norman family of Vieuxpont and utilises the ancient defences. Vieuxpont's castle consisted of a stone keep built, circa 1203–28, service buildings, a timber palisade and moat. In 1268, Roger Clifford became Lord of Brougham when he married Robert Vieuxpoint's great-granddaughter, and his son, Robert, inherited the castle in 1283. Robert Clifford was a leading figure in Edward I's campaigns against Scotland and added further defences to Brougham Castle. In 1295, Edward I gained control of Penrith, but despite his success against the Scots the town was an inviting target for attacks by them over the last twelve years of his reign and into the early years of Edward II's when Penrith was plundered and burned several times.

Following the Scottish victory at the Battle of Stirling in 1297, a notable Scottish raid on the town (which may have included William Wallace) led to great pillaging and slaughter, with accounts of young children being lifted above their heads on spears and carried around the town. Further Scottish raids on Penrith took place in 1308, 1314, 1345 and 1385, with the town being attacked and burned each time.

Ralph Neville was granted the manor of Penrith in 1396, and as warden of the West March he was responsible for the defence of this area against the Scots. He built the castle soon afterwards, between 1397 and 1399, in its earliest form as a square and sturdy stone fort. Ralph's son Richard, who was the 16th Earl of Warick (1400–60), is credited with building the 'Red Tower' as well as improving many of the defences. Following the death of his son Richard (known as the Kingmaker) in 1471 at the Battle of Barnet, the castle was granted to Richard Duke of Gloucester, who later became the infamous King Richard III. The future king is known to have resided at the castle between 1471 and 1485, as he held the position of Sheriff of Cumberland at this time. His role was to secure the county against the Scots and to keep local influential families under control. Richard carried out many alterations to the castle, including larger windows to light private apartments and added a new gatehouse as well as a tower to improve the defences. When Richard became king in 1483, the castle became part of Crown property and even when he was killed in 1485 it passed into the ownership of Henry VII. The castle was not used again as a permanent residence and surveys from the mid-sixteenth century describe the castle as

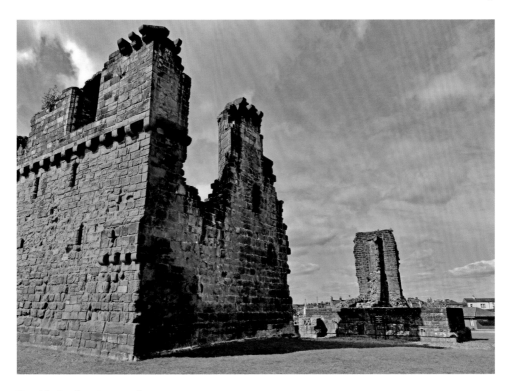

Penrith Castle ruins, north-west corner.

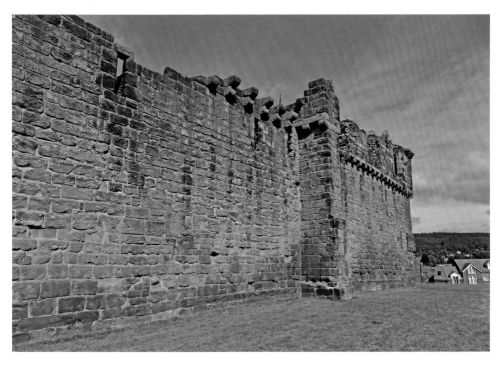

Penrith Castle was an imposing fortress.

partly decayed. In 1547, thirty cartloads of stones are recorded as being taken to build a prison in Penrith; Thomas Carleton had another six cartloads and various other quantities were taken by other residents.

There were further battles and attacks across the border much of which is characterised by the 'Border Reivers'. Reiving was basically local lord – and significant family – sanctioned border raids with the purpose of robbing and burning for personal gain. The taking of cattle, sheep and other goods was a common occurrence along the whole border and was the greatest period for fortified housebuilding. When the two kingdoms were united under James VI of Scotland, who became James I of England in 1603, the border raids reduced and were eventually compelled to stop.

In 1648, during the English Civil War, a Scottish army, led by the Duke of Hamilton, crossed the border in support of the English Royalists. The Parliamentarians were engaged in several sieges throughout the country wereunable to prevent the Scots taking Carlisle in early July. The Scots, with a force of around 12,000 men, marched south in support of King Charles but General John Lambert's Parliamentary Horse were based at Penrith Castle and though not strong enough to fight the invaders, they would use their agility and skill to gain time until they could meet up with Oliver Cromwell. The Parliamentarians knew if they could end the sieges and join up with Lambert, they would be able to defeat Hamilton in the field. It was around this time that what remained secure at the castle was slighted (made indefensible) by the Parliamentarians and rendered useless to the invaders.

Lambert retreated ahead of the Scots down the Stainmore Pass, Appleby Castle fell on 31 July, but he continued to block their route into Yorkshire and prevent any link-up with other Royalist forces besieged at Pontefract Castle. Sir Marmaduke Langdale's Royalist Horse was unable to break through Lambert's cavalry screen and reconnoitre the situation behind his lines, so unsure of what lay before them. The problem for the Scots was that Oliver Cromwell had accepted the surrender of Pembroke Castle on 11 July, and was heading at full speed towards them. Following some rest, resupply and reinforcement in the Midlands, he set off to meet Lambert.

By mid-August, Cromwell and Lambert combined to bring their forces up to around 9,000; though still outnumbered, they were better trained and more experienced. The Scots were strung out from Lancaster to Skipton and oblivious of the approaching Parliamentarian army until they finally clashed on the 17 August 1648 at the Battle of Preston. The Scottish army was scattered and Sir Marmaduke Langdale escaped to Nottingham only to be captured while resting in an alehouse. The Duke of Hamilton surrendered to Lambert at Uttoxeter on 25 August. Sir Marmaduke Langdale was later brought to trial, found guilty of treason and beheaded at Westminster on 9 March 1649.

Charles II, in his attempt to recover the crown, passed through Penrith on his way south from Scotland to his ultimate defeat at Worcester in 1651 and was unhampered by the local authorities. He was at the head of a rabble of an army and escorted by some of the Scottish lords who were intent on defeating Parliament in a final showdown. The local Royalists are said to have lined his processional route through the town and Charles stopped his carriage to show himself to the crowd to salute them all. He was received at

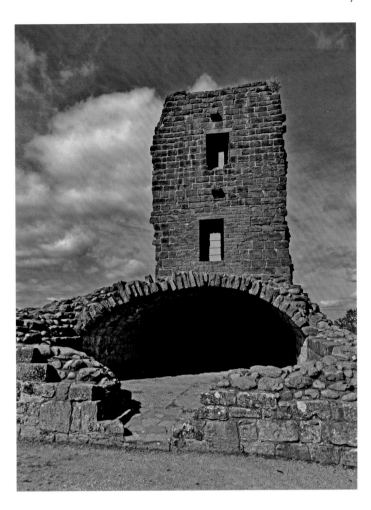

Penrith Castle ruins of
Red Tower.

Carleton Hall to the south of the town by William Carleton before he proceeded south via Westmoreland. He was defeated at Worcester by the Parliamentarians and managed to escape, but remained in exile for almost ten years before the Restoration of the Monarchy in 1660. Many of those that showed support as he passed through the area were rewarded by his favour, including William Carleton who was knighted.

The next conflicts to affect Penrith were the 1715 and 1745 Jacobite Rebellions. These were attempts by the Catholic Stewart dynasty to retake the crown following the ousting of James II of England during the 'Glorious Revolution' in 1688. To maintain the Protestant bloodline, William of Orange and his wife Mary, who was the daughter of James II but a Protestant, were installed as the monarchy. In 1715, James II's son, James Francis Edward, Prince of Wales, nicknamed the Old Pretender, approached Penrith with the Jacobite army. The Bishop of Carlisle assembled a Cumberland and Westmorland militia to the north of the town but the poorly armed militia fled the field and the Jacobites stayed in Penrith before moving south. They were defeated a short time later at the Battle of Preston in November 1715 and support for the cause melted away.

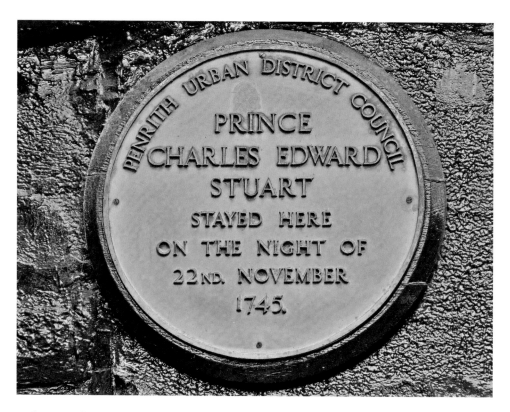

A plaque on the wall of the George Hotel to commemorate Bonnie Prince Charlie's stay during the Jacobite Rebellion.

In 1745 Prince Charles Edward Stuart, son of the Old Pretender, also known as Bonnie Prince Charlie, raised the Jacobites again and following early successes headed south towards London. He is recorded as residing at Penrith during the advance south and following the ignominious retreat north. The 'Young Pretender' as he was also known, stayed in part of the George Hotel, formerly the George and Dragon Inn located in the marketplace, and the town council have placed a plaque on the wall to commemorate this. At Penrith the Jacobites took advantage of the local grand houses and took provisions of hay and oats to sustain their march south. They even made it all the way to Derby but they began to lose their nerve and after some deliberation, turned back for home. The irony is, the way to London at the time was relatively open to them and they stood every chance of success. As they retreated north, the government raised an army and followed the Jacobites until at Clifton, a village just south of Penrith, they clashed. The encounter is only designated a skirmish, but the Battle of Clifton Moor, on 19 December 1745, is claimed to be the last battle on English soil.

The government forces under Wade and the Duke of Cumberland (younger son of George II) who had time to raise a force as the Jacobites retreated were following closely behind. On the 16 December, the Jacobites arrived at Shap on the current A6 road north and rested for the night before moving off the next day, marching on to the village of Clifton. The Jacobite rearguard followed and by the next day the artillery and baggage train was

sent forward to Penrith to meet up with the bulk of the army. The Duke of Cumberland, with aroud 4,000 horse, was around a mile behind them and as Clifton was a defendable position, the Scots committed to remain there. On the 19 December a skirmish broke out between the Jacobite rearguard and around 500 government dragoons. The losses were light with around twelve Jacobite soldiers killed and the government dragoons losing ten men though one British dragoon is believed to have died in Clifton several weeks later. The dragoons killed in the battle are buried in St Cuthbert's churchyard and near to the churchyard gate is a stone commemorating the skirmish. As the Jacobites evacuated Penrith, they are said to have broken into houses and shops plundering whatever they could carry. The retreat north continued until the final collapse of the clans at Culloden in April 1746.

Though this was the last battle on English soil and obviously the last major conflict at Penrith, this was not the last time the town played a pivotal role during world conflict.

Penrith is surrounded by stately homes and during the Second World War their vast remote parklands served as a useful base to train armoured divisions in the use of secret weapons. As early as 1941, Winston Churchill commandeered Brougham Hall and Lowther Park, just south of Penrith, for the development of a top-secret weapon. The Canal Defence Light (CDL) was a weapon based upon the use of a powerful searchlight mounted on a tank and was intended to be used during night-time attacks. The light would highlight enemy positions making them easier to target but with a secondary use to dazzle and disorient enemy troops, making it harder for them to return accurate fire. The name Canal Defence Light was part of the deception regarding the device's true purpose.

A Matilda tank had a modified turret that mounted a powerful carbon-arc searchlight, which was estimated at the equivalent of 13-million candlepower. It was expected that later on another variant or an American supplied tank would take over the role, as although

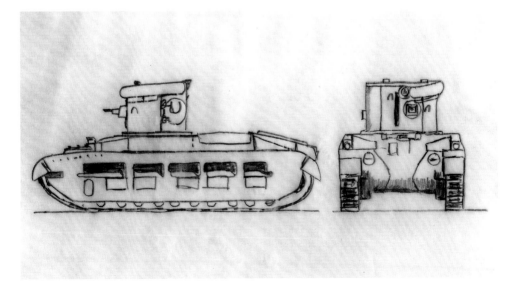

A sketch showing the unusual turret of the Matilda Tank in the CDL variant.

the Matilda was well armoured, it was slow and had an underpowered main gun. The Matilda was originally designed as an infantry support tank and not as an offensive fast moving weapon, demonstrated so effectively by the Germans during the battle for France in 1940. The only surviving CDL-equipped Matilda tank is in the impressive collection at The Tank Museum, at Bovington in Dorset.

A rumour circulating the area at the time was that the army were developing a science-fictional death ray. The bright beams of light were seen in the Cumbrian night sky by the locals and imagination filled in the gaps of knowledge, much like conspiracy theorists today. The army drove about the countryside learning to operate their specialised vehicles by advancing on selected targets with their lights beaming away and fuelling the rumours already thriving amongst locals.

It was soon understood, following these trials, the CDL searchlight beam only blinded the defenders directly in front and not the defence in depth. The lights silhouetted the attackers to any enemy on the flanks or would highlight to the enemy your location. The system could only be used in the case of frontal assault or if the circumstances were very favourable to the attacker. The CDL was never used for its intended purpose and only saw use by US forces in protecting bridges after the crossing of the Rhine in March 1945. The Germans tried to attack the bridges at night using swimmers and floating mines, but with the armoured CDLs in position their task was so much more difficult.

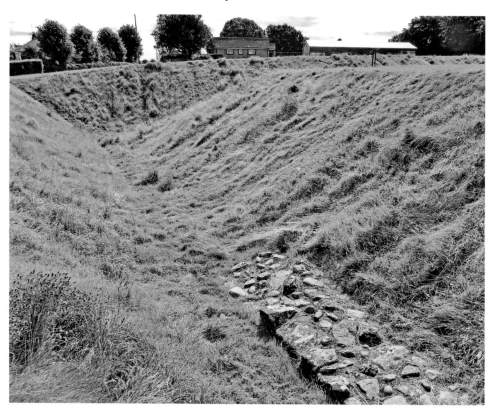

Penrith Castle moat and part of the remaining wall of the gatehouse.

The CDLs were more suited to this task than conventional searchlights because in some areas the east bank was held by German forces who subjected the CDL tanks to artillery and small-arms fire.

Other estates in the area like Greystoke near Penrith were used as training grounds but further east along the A66 is the Warcop Training Centre, established in 1942 as a tank gunnery range. Almost all the armoured formations that took part in the D-Day landings trained here or in the parkland and challenging terrain around the Penrith area.

In summary, Penrith has always been a crossroads for conflict, originally occupied by the Carvetii (ancient British tribe), but conquered by the Romans, the Angles, the Vikings, the Scots and finally the Normans. Penrith is built in a defensive pattern with sturdy buildings around a central market area and with high points to raise the alarm during the time of raids. All these invaders or settlers have influenced the town, its character and its make up today.

DID YOU KNOW THAT...?

The official seal of Penrith had been missing for hundreds of years and was eventually found in the nineteenth century over twenty miles away at Brampton. The seal, around 8 cm across, is made of brass and copper, bearing the cross of St Andrew and the inscription *Sigillum commune ville de Penreth* (or the 'Common Seal of the Town of Penrith'). It was probably dropped during one of the many Scottish raids on the town and left behind as too heavy and worthless.

3. The Industries

The early economy of Penrith is derived from its right to hold markets at the heart of a rural community with established communication links. This right was granted in 1223 by king Henry III, when he also allowed for special great fairs where the buying and selling of cattle and horses was prevalent. As early as 1310 dying, weaving and tanneries are mentioned, but some industry must have been present to supply Brougham Castle from as early as the 1200s and later Penrith Castle after 1397. In 1400 Bishop Strickland of Carlisle had a water supply called Thacka Beck (see Section 7) diverted from the River Petteril to the north of Penrith for the benefit of local industries and the general population.

In 1688 it is recorded by a Mr T. Denton that there is a thriving market and four trade guilds of merchants, tanners, shoemakers and skinners. Stone quarries and slate quarries were located on Penrith fell and a number still survive who supply Cumbrian stone or hard aggregates. During the second half of the seventeenth century and the first half of the eighteenth, Penrith also appears to have been the centre of the pewter industry in the county. Abraham Crawley (1698–1760) is one of the best known of the Penrith pewterers with some examples of his work on display in the Penrith and Eden Museum. Other pewterers included the Cookson family, Lancelot Smith (1637–1707), John Grave (died 1717) and Thomas Grave (1690–1763), all of whom supplied many of the local churches with flagons and plates. They also supplied the local gentry and an indication of the extent of Lancelot Smith's business is that he was able to supply Lady Anne Clifford in 1668 with a large quantity of domestic pewter. Some was destined for her own use and some was intended as a gift for her steward Mr Gilmore. In her account book there appears the following entry:

> Disbursements for 6 Jun 1668 Payed the 6th day to Lanclott Smith for severall sorts of Pewther dishes, chamber potts, flaggons plaites salts & other things for my owne house Use Seaven pounds - Sixteene shillings & six pence as will appear in perticulers by the Booke. 7-16-6 payed then to him which I intend to give to Mr Gilmoore viz: pewther dishes, salts, Candestickes, porrengers Chamber potts One flagon, Tankard & hand bason as will appeare in perticulers by the Book Three Pounds Eighteen shillinges. 3.18.012 Lady Anne Clifford's purchases would amount in total to about two hundred pounds weight and the fact that, in view of her connections, she chose to patronise a local pewterer says much for his reputation at the time (Finlay, 1985).

Transport around the area had historically been by using the old packhorse routes but as industry grew the need to move people and goods efficiently was essential for trade. This need to improve transport links led to a period of building roads known as 'turnpikes',

which were roads managed by consortiums of businessmen and the upkeep paid for by tolls. In a period of twenty years from 1751, nearly 400 new turnpikes were sanctioned throughout the country and many existing roads improved.

Local turnpikes and dates:
Carlisle-Eamont Bridge – 1753
Brough-Eamont Bridge – 1753
Penrith-Chalk Beck – 1753
Appleby-Kendal, Orton-Shap, Tebay-Brough – 1761
Hesket Newmarket-Cockermouth-Keswick-Kendal-Windermere, Keswick-Penrith – 1762.

It was not until the end of the century, when improvements in road building techniques pioneered by engineers such as Metcalf, Telford and McAdam, led to the widespread renovation and development of the original turnpikes.

Throughout the eighteenth century, Penrith was an important clock-making centre, though the expertise in this industry is known to have started much earlier. The Cheesbrough family were working in the town as early as the mid-seventeenth century and are considered a major name in English clock making during this period. Aaron Cheesbrough was working from 1686–1749, he was married to Jane Clement, the daughter of the renowned London clockmaker William Clement and it is likely Aaron learned from him. Aaron was followed by his son John who also became a fine clockmaker and he died in 1771.

The Cheesbrough clock in St Andrew's Church was installed in the tower probably around 1712 before the new part of the church was built in 1722. There must have been a clock in the church before this, as a clock in the church is recorded as being repaired in 1655. The clock has only one hand to show the hours but this is not unusual, as the minute hand was not added to clocks until mid-1700. The reasons for this are thought to be twofold, one, the technology had advanced enough produce a more accurate clock and two, the increase in factories at the beginning of the industrial revolution meant the owners were more aware of workers timekeeping. The Cheesbrough clock was in pieces within the church until recently, it was restored and positioned in the tower.

Another prominent clockmaker working in Penrith was William Porthouse who was active from around 1740 until his death in 1790. William was not native to Penrith, moving with his parents around 1715 and it is thought he apprenticed to Aaron Cheesbrough to learn his trade. His sons, John, William and George all worked in the business, though William junior left to work in Barnard Castle in the 1760s. The Porthouse clock makers dominated the local market and over 100 Porthouse clocks are known to have been built.

There used to be quite a few factories in the town dedicated to making textiles but this reduced as the Lancashire textile industry took over and began to grow exponentially. Penrith was also known for its tanning industry and its breweries. In 1756, the Old Brewery was built in Stricklandgate, followed in 1758 by the Middlegate Brewery and in 1847, Glasson's Brewery in Roper Street. Glasson's eventually took over most of the local

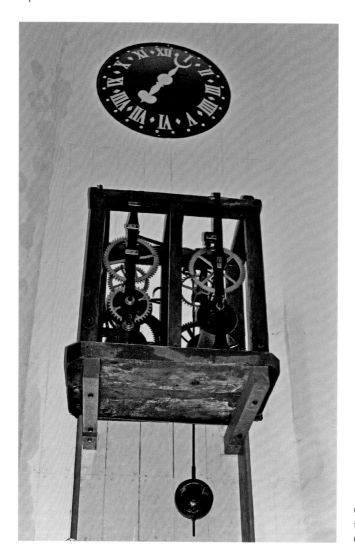

Cheesbrough Clock inside the tower of St Andrew's Church.

breweries but was itself taken over by Dutton's Blackburn Brewery in 1959 and was closed down with the last of the brewery buildings being demolished in 1987. At one time five breweries were located in the town and they served fifty-seven public houses at peak. At a time when the town's population numbered around 9,000, there was a public house for every 157 people and some of those must have been teetotal in an area heavily influenced by Methodism.

A map of 1787 shows the layout of the market area still flourishing with detail of the goods being sold in specific areas, but within twenty years this layout would change. As the town entered the nineteenth century the decision was made to open up the market area. Various old buildings like the market cross, old shambles and moot hall were demolished to make way for an open market area and the development of the Devonshire Arcade. The market area by 1807 was lined with shops, public houses and hotels as the general vista was improved. Not long after the town centre development, the first Penrith

Agricultural Show was held and every year since 1834, this annual celebration has been a popular July event.

From the beginning of the 1800s the population of Penrith began to grow very quickly and developed into the town we see today. The first rail line opened in 1846 with the Lancaster and Carlisle railway, followed by the Eden Valley railway in 1862 and Cockermouth, Keswick and Penrith railway in 1865. This improved the importance of Penrith as a centre of transport and also helped with the increase in tourism to the area. In 1830, a gas company was established, in 1854 a waterworks was built but in 1850 a Penrith Building Society was formed to facilitate new house building in the areas outside the medieval centre. The town continued to be the centre of an agricultural community, with its markets but it also included a foundry, the breweries and the quarries. As the town grew so did the service industries, auction houses, mills, hotels and professional services such as lawyers, teachers and bankers.

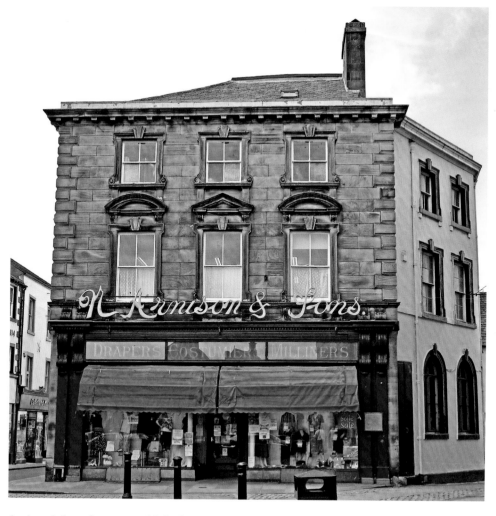

Arnison & Sons drapers, established in 1742.

The town today still caters to tourism but still maintains some industry and services from the past. Arnison & Sons drapers is still a vibrant shop, there is an animal feed processing factory, quarries, timberworks and a thriving agricultural community. The town has recently been through a period of development, with new shopping areas, housing developments and a leisure centre. The public house numbers have reduced significantly since their peak and at the time of writing some were still shutting down with uncertain futures. Yet some brewery chains have recently opened new premises following a refurbishment and renamed 'The Dog Beck'.

DID YOU KNOW THAT...?

Not long after the plague of 1598, Penrith was struck by further disaster as a severe famine devastates the area. Following a record poor harvest in 1622, the following year resulted in high wheat prices and low sheep prices, which led to famine in the area. Though mainly contained to the north west of the country, Cumberland, Westmoreland and Dumfriesshire suffered particularly and there was a significant rise in burials at this time estimated to be around 20 per cent of the population.

4. Education

Penrith has a long tradition of education and as far back as 1340 the Bishop of Carlisle, John Kirby, granted a licence to John de Eskeheved 'to teach the art of grammar'. In 1361, a licence was granted to Robert de Burgham to teach the Prayer Book, Latin grammar and singing, and in 1395 Bishop Strickland founded the chantry in the parish church, paying a chantry priest to teach music and grammar. The chantry was dissolved in 1547 following the Reformation during the reign of Henry VIII. However in 1564, Elizabeth I endowed a Free Grammar School with £6 a year, which was situated in St Andrew's churchyard and Bishops Yard. The old school building was demolished and built over in 1857 in the Gothic style. It was 1915 before the Queen Elizabeth Grammar school moved to its present grounds on Ullswater Road to the south of the town.

In 1661 Robinson's school was founded for the education of poor girls by a Mr W. Robinson, a man of substance in London, who was originally from the parish of

Former Grammar School building located in St Andrew's churchyard.

Penrith. In his will dated 6 August, 1661 he left a patronage of £55 to be paid annually from his tenements in Grub Street, London, by the Grocers' Company to the churchwardens of Penrith. Some of the endowment was to be used by local charities to help the poor, but the sum of £20 per annum, was forever to be used for the educating and bringing up of poor girls to read, write, knit and sew or other learning for girls whose parents cannot afford to pay for their education.

The school located in Middlegate, now the Penrith and Eden Museum, is assumed to have opened in 1670, as the date in the inscription above the doorway. In 1671, the original endowment was added to with the interest from £100 left by a Mrs J. Lascelles of Penrith, as well as various other donations, amounting to £60, of which £40 was expended in the purchase of land. These donations meant the yearly revenue of the school was now about £32 and would now equate to an income value of approximately £148,000 per year.

A register book from 1700 sets out the school rules and makes a list of twenty-nine pupils. The rules expected the mistress to be rather sombre and strict, but must to be capable of teaching all aspects of a young girl's educational needs, including reading and writing. The children were to be punished for lying, swearing, stealing or arguing as you

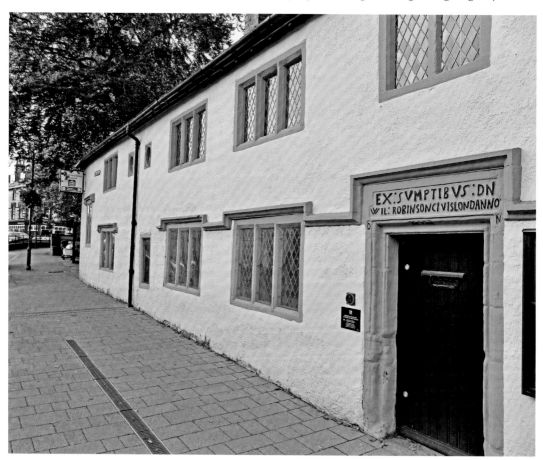

Robinson School in Middlegate, now the Penrith and Eden Museum.

would expect, but also to pay for any damage. As they were all poor girls 'paying for damage' was a threat more likely to be preventative, than enforceable.

Later a separate Spinning and Knitting School was established in the upper room of the school but was removed after 1870 when the building was remodelled in order to make it more suitable for an Infants School. It is also recorded that the good old Victorians condemned the school, stating there was no room for marching! Further improvements were made in 1895 but the school finally closed after 300 years in 1971.

Miss Kathleen Shaul, who joined the school as a teacher in 1939, was the last headmistress. The school still had about sixty pupils with the importance reading, writing and arithmetic their main emphasis, but needlework and knitting skills were still part of the lessons learnt at the school. In 1970 the school celebrate its 300th anniversary with the pupils filed in procession, carrying a special banner bearing the Latin inscription above the school doorway, to St Andrew's Church led by the Miss Shaul and the vicar for a service. Following the closure the children moved to a new school on the Scaws Estate, called the Beaconside School.

In 1977–78 the Penrith Civic Society converted the old Robinson's schoolyard into a seating area and included a millstone with some historical information concerning Thacka Beck. It is at this point here and behind the old schoolhouse that Thacka Beck can still be seen most easily in town. In 1984, the old building became the museum and

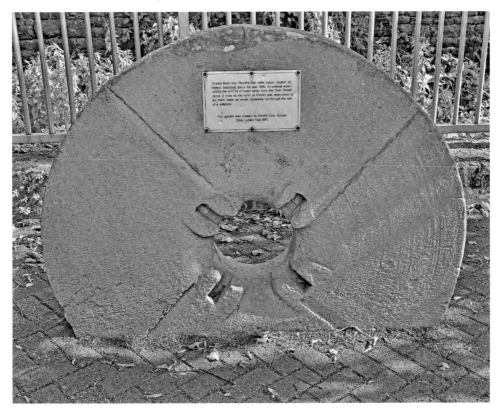

Millstone set in the old schoolyard.

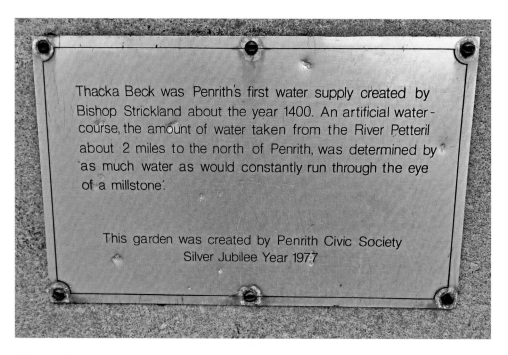

Thacka Beck was Penrith's first water supply created by Bishop Strickland about the year 1400. An artificial water-course, the amount of water taken from the River Petteril about 2 miles to the north of Penrith, was determined by 'as much water as would constantly run through the eye of a millstone'.

This garden was created by Penrith Civic Society Silver Jubilee Year 1977

Millstone plaque.

information centre with collections brought from the old Penrith Museum, which had been housed in the town hall. 1990 saw the building extended to include the Penrith Tourism Information Centre.

Overlooking St Andrew's churchyard is what is likely to be the oldest domestic building in Penrith, it is believed to be Roger Bartram's house and has the inscription 'RB 1563' just below the uppermost window. This building later became Dame Birkett's School and whose claim to fame is William Wordsworth, his sister Dorothy and his future wife Mary Hutchinson all received their early education at this establishment. The building has been and is, at the time of writing, a café with a very appealing aspect to while away the time.

In the nineteenth century the 'age of educational reform', a Girls National School was established in 1813, at the junction of Drovers Lane and Graham Street. It was rebuilt in 1853 and enlarged in 1882 with additional space for infants but is not now used as a school. In 1816 a Boys National School was established on Benson Row on ground given by the late Earl of Lonsdale but was rebuilt in the Gothic style in 1871 and closed in 1979.

There was also a series of primary schools established during this period to cater for the different religious needs such as the Church of England (1833), Wesleyan (1844) and Catholic (1882). On top of this was a series of small independent private or boarding schools including what was called the British School, erected in 1847, just to the side of Auction Mart Lane, opposite the castle.

In the later twentieth century Tynefield (girls) school and Ullswater (boys) school merged to become Ullswater High school, which has since become Ullswater Community College. Penrith has a strong historical association with education and for over 675 years children from all backgrounds have had the chance of an education.

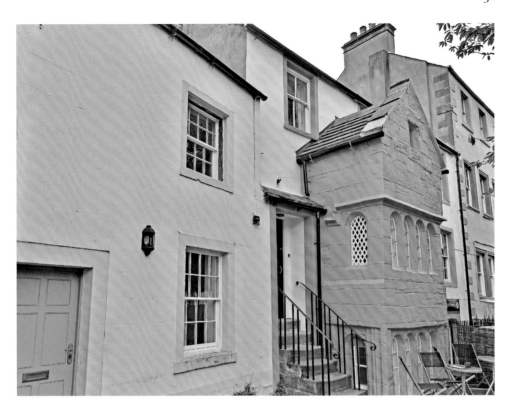

The former school attended by William Wordsworth and his sister Dorothy.

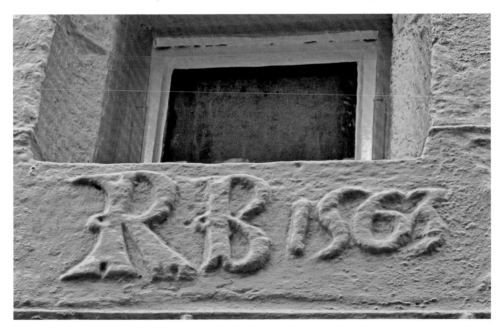

The inscription above the door is believed to stand for Roger Bartram 1563. One of the oldest dwelling buildings in Penrith.

DID YOU KNOW THAT…?

Around 1770, a schoolmaster at Penrith called Mr Daws laid for several days as a corpse and narrowly escaped a premature burial, by awakening from his trance on the shoulders of his coffin bearers according to the *Mannix & Whellan, History, Gazetteer and Directory of Cumberland*, 1847.

DID YOU KNOW THAT…?

The second Sunday in May used to be called Shaking-bottle Day. Bottles were filled with water from the local well and pieces of liquorice were added and shaken until froth was formed. This sugary concoction's froth was then drunk and known as 'Spanish water'. Shaking-bottle Day started to die out after the 1850s as the day had a bad reputation for fighting and 'other irregularities'. Apparently in parts of Cumbria liquorice is still known as 'Spanish'.

5. People

There are very few records detailing the population of Penrith before the official census which began in 1801, but estimates in 1688 suggest a population of around 1,350 souls. Yet according to an inscription on a brass plaque in the church, 2260 people died in the 1597/78 outbreak of the plague and if you use the typical loss rate of around 33 per cent to 45 per cent, the population could have been as high as 6,000 at the time. It is however, most likely, the high figure relates to the entire Penrith Deanery which encompasses all the surrounding rural areas and villages. But it is still estimated the 1597/98 plague killed over 600 individuals in Penrith, putting the population nearer to 1500, and it took about 100 years for the numbers to recover. The reason for the long population recovery period may have also been due to a famine which affected the area in the 1620s and took a further 20 per cent from the inhabitants. The plague had visited the area before this outbreak, but the 1597/78 one is the best recorded event and it has been more recently suggested that the epidemic was not spread by rodents as usually thought. Records show the disease spread in Penrith from a man travelling from Richmond, North Yorkshire, called Andrew Hogson who was lodging in King Street. Duncan and Scott are convinced the disease was not bubonic plague, carried by the fleas that lived on rats, but another highly infectious and deadly virus called haemorrhagic plague. The plague victims soon filled the churchyard and new burial pits were dug closer to the fell side in an area called 'Plague Lonnin' (now situated between Wordsworth Street and Graham Street).

Population of Penrith*
1688 – 1,350
1769 – 2,000
1801 – 3,801
1851 – 7,387
1918 – 8,973
1991 – 12,059
2001 – 14,756
2011 – 15,181

*Figures based on the census or estimates from earlier historical documents

From the table above it is clear the population of Penrith only grew slightly over the next 250 years but after 1801, increases significantly. Between 1845 and 1865 the arrival of the railways saw the population rise by double from 3,801 in 1801 to nearly 8,000 only fifty years later. The railways also brought tourists to the area which has been a booming industry ever since, even as rail transport gave way to the motor vehicle the visitor numbers continued to rise. By 2011 the population had grown to more than 15,000 people.

Though the area had been visited in the past by writers such as Celia Fiennes and Daniel Defoe, it was 1778 when Father Thomas West published *A Guide to the Lakes*. This is considered to be the first real tourist guide, he recommends the finest locations for visitors to stand and appreciate the landscape of the area. In 1820, William Wordsworth, a man who had been brought up in the area, published his own guidebook *A Guide Through the District of the Lakes in the North of England*. A man of foresight, he even suggested that the Lake District should become 'a sort of national property', but objected to the building of the railways and roads, which have since allowed ever-increasing numbers of people to visit the area. Wordsworth's work became very popular and combined with the writings of poets such as Southey and Coleridge, the Lake District was being promoted for its beauty and splendour. At this time the industrial revolution was in full expansion, with factories, mills and workshops taking over many towns. With this industry came the filth and squalor and there were many who were keen to escape the stench of the growing conurbations. Where better than the fells and dales of the Lake District to take the fresh air and explore an unspoilt landscape. The reality is the hand of man can be seen in every field and hillside of the region.

Political upheaval following the French Revolution and the Napoleonic Wars in Europe also meant that wealthy tourists, who would have usually visited the great cities of Europe, were looking for different travel options in this country. There was also a resurgence of landscape artists who looked to visit the Lake District and the magnificent scenery available to them. Joseph Mallord William Turner, one of our finest landscape artists, visited Penrith in 1809 and 1831, he sketched Penrith Castle, Mayburgh Henge and Beacon Hill in his notebooks. Encouraged by the Earl of Lonsdale, he painted the surrounding area including *Lowther Castle – Evening*, a painting which now hangs in the Bowes Museum at Barnard Castle.

Interest in the Lake District continued to grow as the roads and railways improved and provided easier access to the area. The publication of the *Pictorial Guides to the Lakeland Fells* by Alfred Wainwright in the mid-1950s and early 1960s provided detailed information on 214 fells across the region, which proved a draw for ramblers keen to follow in his footsteps. The Lake District attracts circa 15 million visitors per year (lakedistrict.gov.uk) and with Penrith as the gateway to the Northern Fells, the town provides a vital service to the tourist industry.

Penrith has produced or been a residence for some interesting characters throughout history, some of which have had a profound effect on our everyday lives.

William Strickland, Bishop of Carlisle

William Strickland was born into the Strickland family of Sizergh in 1336 and became the Bishop of Carlisle but had a major influence on the Penrith area. It is believed he served as the rector of Ousby and parson of Rothbury before becoming the chaplain to Thomas Appleby, Bishop of Carlisle. He was appointed bishop himself in 1396 by Pope Boniface IX, but was not at first accepted by the King. He was not recognised until 1400, after he had been elected by the chapter and agreement reached with the King, Strickland was then consecrated by the Archbishop of York at Cawood, in Yorkshire, on 24 August.

Strickland was one of the commissioners sent to negotiate peace with Scotland in 1401 and in 1402 was engaged to arrest any persons suspected of claiming that Richard II was

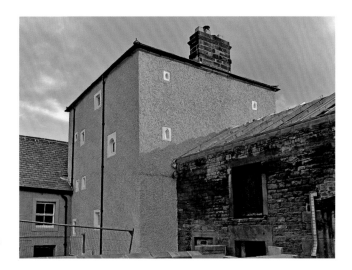

Hutton Hall tower believed to have been built by William Strickland.

still alive (it is believed he starved to death at Pontefract Castle). In 1404 he was granted the office of constable of Rose Castle and Strickland was one of the witnesses of the act declaring the succession to the crown in 1406.

Strickland held lands around Penrith and during the reign of Richard II he was given license to crenellate but it is uncertain if this was part of Hutton Hall or the castle (see Section 6). Though he added a tower and belfry to his cathedral in Carlisle and built the tower at Rose Castle, one of his main achievements was his cutting a watercourse, known as Thacka Beck, from the river Petterill, through the town of Penrith and on to the river Eamont (see Section 7).

Strickland died in 1419 at Rose Castle and was buried in the north aisle of Carlisle Cathedral as he requested in his will.

Richard III

Richard, Duke of Gloucester was a resident of Penrith and is believed to have lived at The Gloucester Arms or Dockray Hall as it was called then, while he awaited modifications and enhancements to be carried out on the castle.

During the War of the Roses the Neville family, who built Penrith Castle, supported the Yorkist cause and indeed it was Richard Neville, 16th Earl of Warwick (known as the Kingmaker), who was instrumental in Edward IV obtaining his crown. However, they disagreed over Edward's choice of queen in Elizabeth Woodville and when a plot to crown Edward's brother, George, Duke of Clarence, totally failed, Warwick helped restore the Lancastrian Henry VI to the throne. This conflict culminated in the Battle of Barnet in 1471 where fog and confusion on the battlefield ended with Richard Neville being killed. Edward IV, grateful for the support of his brother Richard Duke of Gloucester, granted him the Neville estates which included Penrith. Richard's grip on the north was further strengthened when in February 1475 he was appointed Sheriff of Cumberland for life. Richard carried out alterations to Penrith Castle to transform it into a suitable residence for the brother of the king of England and a more comfortable home to fulfil his new duties. He added a new gatehouse and a tower to improve the defences but also installed

Great Dockray with Dockray Hall or The Gloucester Arms in the centre of the photograph.

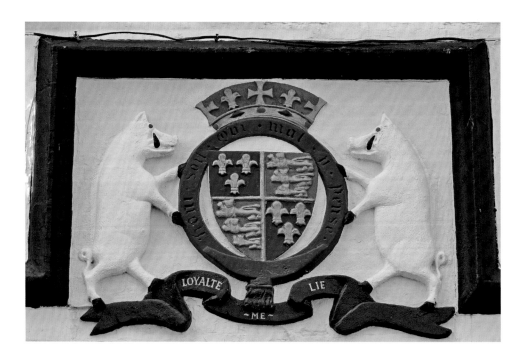

The white boar crest of Richard III above the entrance of The Gloucester Arms.

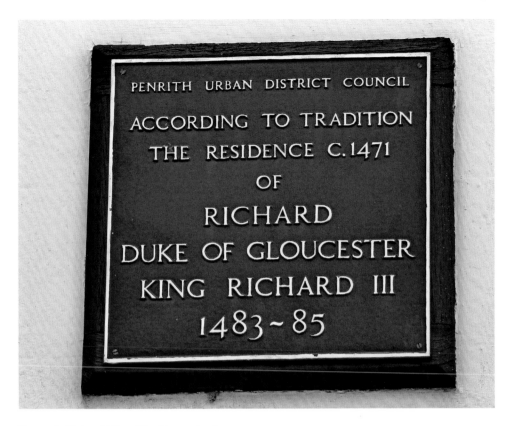

PENRITH URBAN DISTRICT COUNCIL

ACCORDING TO TRADITION
THE RESIDENCE C.1471
OF
RICHARD
DUKE OF GLOUCESTER
KING RICHARD III
1483~85

Plaque to Richard III on The Gloucester Arms.

larger windows to light his private accommodation. His tenure as custodian of the castle ended in 1485 on the field of Bosworth when Richard was defeated in battle by Henry Tudor, this ended the War of the Roses and the Tudor period began.

Lady Anne Clifford

Lady Anne Clifford, Countess Dowager of Dorset, Pembroke and Montgomery, *suo jure* (in his/her right) 14th Baroness de Clifford was an extraordinary woman of her time and had strong links to the area, but especially Brougham. She was born at Skipton Castle, North Yorkshire in 1590 during the reign of Elizabeth I, but into a man's world where a woman was more or less the property of her husband. Lady Anne Clifford was the daughter of Sir George Clifford, 3rd Earl of Cumberland, who was a privateer and champion of the Queen.

When she was only fifteen her father died and she was extremely upset to find that she did not inherit her father's vast estate, instead it went to his brother on the male line. From that moment she fought long and hard to recover her inheritance but was thwarted at every step until eventually in 1643, thirty-eight years later, she finally won her case. She married twice, had five children, restored much of her estate and is responsible for a plethora of castles and churches still existing today. This includes many in the Penrith area including Brougham Castle, Brougham Hall and St Ninians Church, known locally as 'Ninekirks', situated just west of the town. She lived through

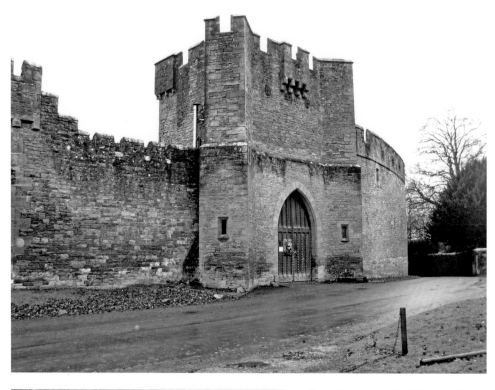

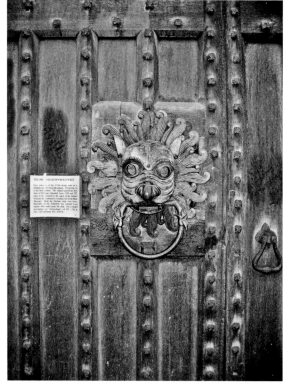

Above: Brougham Hall is one of Lady Anne Clifford's old properties.

Left: One of the fine door knockers at Brougham Hall.

troubled times: the death of Elizabeth I, the joining of the Scottish and English Crowns, the civil war, the death of Charles I and eventually died during the reign of Charles II. She was also hereditary High Sheriff of Westmorland from 1606 to 1676 and the legacy of the woman is still with us now in the various castles, houses and churches throughout Yorkshire and Cumbria.

Thomas Nelson

Thomas Nelson, one of the first signatories of The Declaration of Independence was the grandson of Thomas Nelson, who was known as 'Scotch Tom' and was born on 20 February, 1677 at Penrith. Records indicate 'Scotch Tom' went to America around 1690 and was involved in the layout of Yorktown, and as a merchant was involved in building the first custom house in the colony. He later built Nelson House around 1740 with his son William Nelson, father of Thomas Nelson, Jnr who was only an infant. This house played an important role in the American victory over the British at Yorktown in 1781 during the American War of Independence. During the siege of Yorktown, Nelson was to lead the Virginia Militia, whom he had raised and funded, and legend has it he ordered the artillery to direct their fire on his own house, which was occupied by the British General Cornwallis. The house must have been well built as it still stands but there are three cannon balls still lodged on the outer wall of the house.

Nelson House, built by 'Scotch Tom' Nelson from Penrith, is a National Historical Landmark maintained by the Colonial National Historical Park of the US National Park Service.

William Charnley

William Charnley was christened at St Andrew's Church on 20 April 1727, the son of a Penrith haberdasher and is described as a bookseller of some note. He was a collector, business man and knowledgeable seller of every aspect of literature. He was also highly respected for his integrity, his views on social responsibility and his overall sophistication. He began his apprenticeship with Martin Bryson, a Newcastle-upon-Tyne bookseller, located near the Tyne Bridge, and was entered into the 'Stationers and Tin-plate Workers' Company in 1749. He died in 1803, aged seventy-six years as one of the most eminent of Newcastle booksellers.

At the age of fourteen he was a bound apprentice in Newcastle, to Joseph Longstaffe, and afterwards turned over to Martin Bryson, who had been admitted to the freedom of the town in 1725. At the completion of his apprenticeship in 1748, William was admitted to the freedom of the town, and in 1750, he became a partner in the business but it was dissolved in 1755 on Bryson's retirement. William continued the business by himself and in 1757 he added a circulating library to the business. Unfortunately in 1771, his shop was destroyed in the flood that washed away the Tyne Bridge and by 1773 he was declared bankrupt, his stock sold, and his circulating library in the hands of a Richard Fisher. William bounced back within a year and by 1777 had taken over a shop in the Groat Market (part of the Bigg Market) and from this time until his death, his bookselling business was probably the largest in Newcastle. He was succeeded by his widow, Elizabeth, and his son, Emerson Charnley.

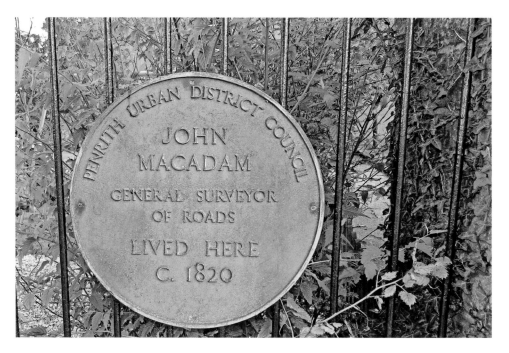

John McAdam plaque on Drovers Lane.

John McAdam

John Loudon McAdam (1756–1836) was a famous road builder and inventor of a new process for building roads with a smooth hard surface. 'Macadamisation' as it was known ,used tar to bind the road surface's stones together and make a harder wearing top surface to a roads construction. This process is familiar to us as 'tarmac' or 'tarmacadam' and changed the quality of roads throughout the world.

McAdam stayed at Cockell House on Drovers Lane around 1820 when he was surveying and supervising the building of new roads from Alston to Penrith, Alston to Brampton and Alston to Hexham. Penrith has honoured this connection to the Scot by naming a street in the town 'Macadam Way'.

Samuel Plimsoll

Plimsoll was born in Bristol in 1824, moved to Sheffield and later came to Penrith. Though his parents were not wealthy he lived at Page Hall in Foster Street for around ten years and was partly educated by the curate of Penrith. He left school at a relatively early age and was employed as a clerk in a brewery, which he ended up managing. While he worked he continued his studies and, being an ambitious man, he made his way to London to try to become a coal merchant. He was unsuccessful and he ended up penniless and living in cheap boarding houses in the dockland area.

His fortunes revived and flourished, eventually becoming a Member of Parliament, and as well as a keen Social Reformer and as part of the Liberal party, he was best known for his changes to the Merchant Shipping Act of 1876. He had an understanding of the struggling poor of the time and directed his efforts against corruption at sea. This involved

heavily insured, but overloaded and unsafe vessels, in which dishonest owners risked the lives of their crews. Though he struggled to have the bill passed and even incurred the wrath of Prime Minister Benjamin Disraeli at one point, the bill was eventually passed. One of the key parts of the Act of 1876 was the use of a series of lines painted onto the hull of a ship to show the maximum safe draft to prevent overloading. This is became known as the Plimsoll line and is still used today.

Today in Townhead, off Scotland Road there is a row of houses called Plimsoll Close after him. There is also a memorial to Samuel Plimsoll on Victoria Embankment in London.

Levi Grisdale

Buried in the graveyard of Christ Church in Penrith is a seventy-two-year-old 'Chelsea Pensioner' who died of 'dropsy' (now known as oedema) on 17 November 1855. Levi Grisdale was born to a farming family in Matterdale in 1783 but at twenty years of age he enlisted in the 10th Light Dragoons, soon to be the Hussars. This was the time of the Napoleonic Wars and in October 1808 the 10th Hussars embarked at Portsmouth heading for Spain. The Peninsular War (1807–14) was an attempt by the allies of Spain, Britain and Portugal to take control of the Iberian Peninsula from the French occupiers. In an early battle of the war Levi Grisdale is credited as being involved in the capture of General Charles Lefebvre-Desnouettes who was an elite French cavalry officer and favourite of Napoleon. In 1809, the 10th Hussars were evacuated from the conflict and returned to England.

Levi was back in the peninsular by 1813, but now promoted to Sergeant and celebrating ten years with the regiment. He was part of a coalition army under Field Marshal Arthur Wellesley, who would become better known as the Duke of Wellington. The 10th Hussars fought their way through Portugal, Spain and France until the Battle of Toulouse in April 1814. Napoleon's Grand Armée was not the fighting force it once was following the disastrous retreat from Russia in 1812 and with the allies closing in on all sides, Napoleon abdicated only to be exiled to Elba.

Within a year Napoleon escaped, arrived back in France and recalled his army. His ambition was finally ended when he was defeated at the Battle of Waterloo on 18 June 1815. The outcome of Waterloo was far from certain and with the allies 'toe to toe' with the French all day, it was not until the arrival of the Prussian army under Prince von Blücher, that the decisive blow was struck. The soldier credited with leading Blücher onto the field is Sergeant Levi Grisdale, having been posted on the road where the Prussians were likely to arrive.

He remained with the Hussars for another nine years and was promoted to Sergeant Major. When he left the army in 1825, at the age of forty-two he is said to be suffering from chronic rheumatism and was defined as 'worn out by service'. He was given an army pension and became the landlord of the Stag and Star public house in Bristol. For whatever reason by 1832, Levi and his family had moved back to his homeland and were residing in Penrith. His wife Ann died there in July of that year and is buried at St Andrew's Church as 'Ann Grisdale wife of Levi of Netherend'. He must have been a man of action as two weeks later, Levi married a local lass called Mary Western and went on to

have four children. The last child was born when he was aged sixty-two and the words on his discharge papers stating he was 'worn out by service' now seem a little hollow.

In 1834 Levi is known to have been a retailer of beer at Netherend and in 1835 he is described as an Innkeeper. The inn was called 'The General Lefebvre', after his famous escapade, and apparently included a picture of the general above the door. Within two years he was living in Great Dockray and is employed as a gardener. By the time of the 1851 census he is listed as a chelsea pensioner and a pensioner he may have been, but one who certainly led a very colourful life.

William Pearson

There is a plaque fixed to the wall of Mitre House, No. 16 King Street with the inscription 'Here resided Trooper William Pearson 4th Light Dragoons. Born 1828 – died 1903 charged with the Light Brigade at Balaklava 1854'. William Pearson (1826–1909: note different to the plaque), was a combatant of the Crimean War who took part in the renowned 'Charge of the Light Brigade'. The Crimean War (1853–56) was fought by an alliance of France, the United Kingdom and the Ottoman Empire against Russian Imperial expansion.

William Pearson was born in King Street in what was formerly the Mitre Hotel in 1826 and became a leather dresser before running away to join the 4th Light Dragoons in 1848. The Charge of the Light Brigade is infamous because it involved lightly armed cavalrymen with lances and sabres bounding headlong into a valley brimming with Russian cannon. It was Lord Tennyson who suggested in his well-known poem that somebody blundered on that day.

> Into the valley of Death rode the six hundred.
> Cannon to the right of them, cannon to the left of them, cannon in front of them.

Evidence suggests an unclear or misinterpreted order resulted in the Earl of Cardigan leading a charge by 673 cavalrymen into intense cannon fire where 270 were killed or wounded and where they lost approximately 375 horses in the process. During the charge, William Pearson's horse fell over another that had already tumbled and he had to mount a rider-less horse of the 8th Hussars. He had an epaulette shot from his shoulder and was wounded on his forehead during the battle.

Later during the campaign, as many soldiers of the time, he suffered frost-bite during the harsh Crimean winter and spent Christmas Eve 1854 having four toes amputated. He recuperated in the hospital in Scutari, the hospital made famous by Florence Nightingale, and was later invalided home.

He was presented before Queen Victoria in 1855, received the Crimea Medal, Turkish Medal and a Good Conduct Badge before being discharged as unfit for further military service. He returned to Penrith with a wife he met in Dover and became the inspecting officer's orderly to the Dalemain Troop, Cumberland and Westmorland Imperial Yeomanry. In 1880 he moved to Underbarrow, near Kendal, where he set up a fellmongering (a dealer in hides or skins, particularly sheepskins) and tanning business. Retiring in 1906, he died in July 1909, aged eighty-two, and was buried with military honours in Parkside Cemetery, Kendal.

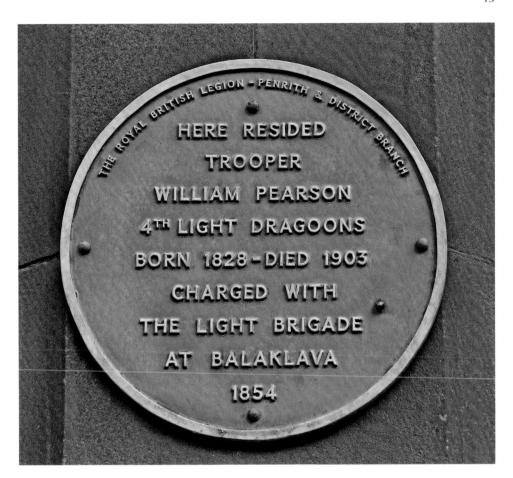

The plaque to William Pearson, Charge of the Light Brigade veteran, located in King Street.

Charles Graham Robertson

Charles Graham Robertson was awarded this country's highest honour, the Victoria Cross, in 1918 and is listed as born in Penrith. But may actually have been born in Yorkshire and brought up by his relatives who lived in Graham Street, off Drovers Lane in Penrith. He was a Lance Corporal in the 10th Battalion, Royal Fusiliers and was awarded the medal for conspicuous bravery in Belgium during the First World War. His full citation is below:

For conspicuous bravery in repelling a strong attack by the enemy on the 8th/9th March, 1918 near Polderhoek Chateau, Belgium. Realising that they were cut off, Lance-Corporal Robertson sent two men to get reinforcements, while remaining at his post, along with one other man, firing his Lewis gun and killing large numbers of the enemy. No reinforcements came. Realising that he was completely cut off, he withdrew, with the only other survivor, took a place 10 yards to the rear. Here he successfully defended his position, staying for some time, firing his gun and inflicting casualties on the enemy. He was forced to withdraw again when the position came under heavy hostile bombing and machine-gun fire. Arriving at a defended post, he and a comrade mounted a machine

gun in a shell-hole. From this position they kept up a continuous fire at the enemy who were now pouring into an adjacent trench. They had not been firing long when his comrade was killed. Lance-Corporal Robertson was to also wounded. In this condition he crawled back with his machine gun, being unable to fire it as he had exhausted all of the ammunition.

South Penrith Robbers

Not all the people of Penrith have been of a productive, god-fearing nature and a valuable part of the community. In the early nineteenth century a notorious gang of criminals infested the highways and countryside to the west and south of the town. John Woofe, William Armstrong, John Little and William Tweddle for a period of eighteen months terrorised the locals returning from the Tuesday market days. The gang were known for their use of violence and implementation of sinister methodology to achieve their ends. They are known to have dug a grave beforehand for a victim, strung wire between trees to unhorse riders and committed burglaries with masks, guns and swords.

In the end the people of Penrith revived the old border warning system of 'watch and ward' with volunteers supplied with a rattle and a bludgeon to guard the town. The apprehension of the gang was due to one victim recognising William Tweddle who was immediately arrested and turned King's Evidence. Woofe and Armstrong were arrested, but Little absconded to Newcastle only to be arrested later and all were committed to the assizes at Carlisle in August 1820.

Woof, Armstrong and Sowerby were sentenced to death for house breaking and were executed at the old gaol in Carlisle on 2 September 1820. Tweddle was transported to Van Diemen's Land (now known as Tasmania), and is said to have joined a group of outlaws who eventually hanged him as a known informer.

Francis Percy Toplis

In an unmarked grave towards the top of the Beacon Edge Cemetery is buried one Francis Percy Toplis; he is not even from the parish, but was killed near Penrith in 1920. He became the subject of a book in 1978 and was adapted for television by Alan Bleasdale in 1986. Toplis is now more familiar to us as 'The Monocled Mutineer' which portrayed him more as a hero than as a brigand he seems to have been in real life.

He was raised in Derbyshire by a succession of family members and was an unruly child, often in trouble and was even birched aged eleven. Leaving school at the age of thirteen, he became a blacksmith's apprentice, but was dismissed soon after and began to travel around partaking in petty crime. In 1912, aged fifteen, he was sentenced to two years' hard labour for the attempted rape of a fifteen-year-old girl at Mansfield, serving his sentence in Lincoln Prison.

Following his release from prison he joined the Royal Army Medical Corps (RAMC) and served as a stretcher bearer until 1915 when they became part of the force sent to Gallipoli. The campaign was an utter disaster and conditions were horrific and when they returned Toplis was hospitalised with dysentery. He was given light duties in a munitions factory at Gretna before being posted to Salonika and Egypt where he contracted malaria

and had to be shipped home. In September 1917 his unit was shipped to Bombay for some months and then returned to Britain.

The television production portrays him as hero of a riot which broke out among British troops, in September 1917, during the First World War, near Etaples, in France. However, in respect to the life of this Percy Toplis, he was not even near the area and is considered pure fiction. To be fair to the authors and production teams, there were a few soldiers with the name Toplis and the story seems to connect them together.

He was stationed at RAMC Blackpool but deserted shortly after the death of his father in August 1918. He was sentenced at Nottingham Assizes to two years imprisonment for fraud and yet when he was released in 1920, he was allowed to join the Royal Army Service Corps, and was stationed in Bulford, near Andover. He was soon up to no good selling black market army fuel, forging false papers and wearing a colonel's uniform when he visited women in town. To complete his deception he would often wear a monocle which is the reason for the literary nickname.

Toplis deserted again but this time a taxi driver was found shot dead on Thruxton Down near Andover and Toplis was accused of the murder. At twenty-three years of age Toplis was on the run again and headed to Scotland but after a spell of cold weather he lit a fire in a remote gamekeeper's cottage. The smoke was seen by a hill farmer and returned with the gamekeeper as well as the police. Toplis took out a revolver and fired several shots, wounding them before escaping on a bicycle. This he abandoned at Aberdeen, and travelled south by rail, arriving in Carlisle.

The Beacon on Beacon Hill was built in 1719.

He was spotted sitting beside the Carlisle to Penrith road near Low Hesket by a PC Alfred Isaac Fulton on Sunday, 6 June 1920. And what followed was frantic activity at the Penrith Police Headquarters, the issue of revolvers and the officers taking cover behind farm buildings at Romanway further along the road. Challenged by the police, Toplis was shot at as he tried to run away and was fatally wounded.

Among his possessions was the monocle he wore to impress the ladies; to help pay for the cost of his burial, this along with his other belongings, were handed to the Penrith Board of Guardians. Luckily, Councillor Johnstone, a member of the board, was also a member of the Penrith Urban District Council Historical Committee and the items were handed over to the Penrith and Eden Museum.

DID YOU KNOW THAT!

Kaiser Wilhelm II, Queen Victoria's nephew and German Emperor was in Penrith twice before the First World War to visit to Lowther Castle as the guest of Lord Lonsdale, once in 1895 and again in 1902? The last visit was only twelve years before hostilities broke out between the two nations.

DID YOU KNOW THAT...?

The churchyard of St Andrew's contains the grave of John and Mary Hutchinson, parents of William Wordsworth's wife Mary.

DID YOU KNOW THAT...?

In 1881, Thompson, Hodgson and Wilson are the most common names in Penrith? Smith was only the fifth most common.

6. Buildings

The Beacon

To the north-east of the town is the 939-feet-high Beacon Hill that has served as a place to watch for raiders and alert the townsfolk by way of signal fires. Originally there were similar beacons throughout the country and these formed a primitive early-warning network. The summit has views of Eden Valley, the Pennines (Cross Fell 2,930 feet) and the Lake District Northern Fells (Helvellyn 3,117 feet). To the north, the mountains of Scotland can be seen across the Solway Firth and throughout Penrith's history this was the most likely direction of attack.

The present monument was built in 1719 and replaced an earlier structure. The site is known to have served as a beacon since the thirteenth century and an old map by Saxton in 1579 shows a building on a hill above 'Penreth' as he called the town. In all likelihood there has been a building on this site for more than 500 years. The beacon warned of numerous Scottish raids over the centuries, but did not necessarily stop the town from being attacked and plundered. The beacon was even used during 1745 Jacobite uprising, when Prince Charles Edward attempted to regain the crown for the Stuart Dynasty. The last real use for the tower was during the Napoleonic Wars when the threat of invasion was a genuine worry and meant the beacon was kept in a state of readiness.

The view over Penrith towards the fells of the Lake District from Beacon Edge.

The Cross Keys at Carleton.

Beacon Hill is sometimes referred to as Gibbet Hill or Gallows Hill, as it was the place of execution for criminals or traitors and has a local ghost story known as the 'hanging man'. The story tells of an event in the winter of 1766, when a butcher called Thomas Parker was on his way home after a successful day at Penrith market. He decided to celebrate at the Cross Keys public house (still a public house) in Carleton with his friends, where he drank copious amounts of beer and when he had had enough he set off to walk the last few miles back to Langwathby. The next day his body was found viciously beaten and robbed, not very far from the Cross Keys by the junction between the Langwathby and Beacon roads. Thomas Nicholson, Parker's godson was soon blamed for the murder, tried and sentenced at Carlisle to be hung and gibbeted on Beacon Hill near to where the murder took place. On 31 August 1767, Thomas Nicholson was hanged in front of a large crowd and his body placed in a gibbet (made from metal strips and rivets, the gibbet is designed to house the human body as it rots and provides flesh for the crows to peck at). The body is said to have hung for seven months. The hanging man, the ghost of Thomas Nicholson, is said to make an appearance during harsh winters, with his skeletal remains hanging from a gibbet.

Though Beacon Hill is referred to as Gibbet Hill, the actual site of Nicholson's execution was on an eastward spur of Beacon Hill, near Cowdraik Quarry. This area is now very popular with climbers and would have been clearly visible from the Cross Keys Pub.

Nicholson was not the only man to be executed on the hill. Following the 1745 Jabobite Rebellion (see Section 2), several rebels who were caught fleeing back to Scotland were hung, drawn, and quartered here in 1746.

The Rebellion led to a substantial number of trials for High Treason, with ninety-one sentenced to be hung, drawn and quartered by a Special Commission at Carlisle. Of the ninety-one executions, twenty were to be carried out at Carlisle, six at Brampton and seven at Penrith. The names of the rebels executed in October 1746 at Penrith are as follows:

James Harvey
Robert Lyon
David Home
John Rowbotham
Valentine Holt
Andrew Swan
Philip Hunt

The sentence carried out on these individuals is described below:

That you be drawn on a hurdle to the place of execution where you shall be hanged by the neck and being alive cut down, your privy members shall be cut off and your bowels taken out and burned before you, your head severed from your body and your body divided into four quarters to be disposed of at the King's pleasure.

What may be more of a surprise is that the names don't appear to be very Scottish and this may be due to the fact that there was an English Jacobite Manchester Regiment. It should be remembered that the Jacobite cause was also part of the ongoing conflict between Catholics and Protestants, and as such still attracted dissatisfied English Catholics. This regiment was commanded by Francis Townley who surrendered to the Duke of Cumberland after briefly holding Carlisle in late 1745. The execution of Francis Townley, carried out in London in July 1746, is described thus:

After he had hung for six minutes, he was cut down, and, having life in him, as he lay on the block to be quartered, the executioner gave him several blows on the breast, which not having the effect designed, he immediately cut his throat, after which he took his head off then ripped him open, and took out his bowels and threw them into the fire which consumed them, then he slashed his four quarters, put them with the head into a coffin, and they were deposited till Saturday, August 2nd, when his head was put on Temple Bar, and his body and limbs suffered to be buried.

Robert Lyon, one of those executed at Penrith was a Jacobite minister. The Revd Lyon was chaplain to Lord Ogilvie's regiment and was captured at Carlisle, but all appeals for mercy were turned down by the Duke of Cumberland and he was executed with the others. Many of the rebels, Scottish and English, were 'transported' around the empire

and the Jacobite cause struggled to threaten Britain again. Though in 1759, at the height of the Seven Years' War, Charles encouraged the French to invade England with a sizeable French force to which he hoped to add a number of Jacobites. However, the prospect of invasion was ultimately thwarted by naval defeats upon the French by the British and later, in 1788, Bonnie Prince Charlie died in Rome, being buried in St Peter's Basilica, in Vatican City.

The Beacon Hill area is now part of a commercial woodland area owned by Lowther Estates and is a popular area for walking by both the locals and tourists. The summit has great views of the local fells, Eden Valley, the Northern Lakes and the Pennines.

The Friarage

The Friarage is a Grade II-listed house built in 1717 on the site of an Augustinian friary. The friary was founded circa 1291 during the time of Edward I who gave 2s 8d on his journey to Scotland, and 5s 8d on his return. The friary is thought to have been added to in 1318 and again in 1333, but there are no visible remains today. The Augustines are Grey Friars who followed a poor existence, where possession of private property was not allowed, and they maintained a life of solitude and penance. The friary was dissolved in 1539 during the reign of Henry VIII and the house was granted to Robert Tyrwhit. It is believed the house may stand on top of the foundations of the old buildings and when the

The Friarage is built on the site and probably the foundations of the medieval friary.

Date plaque above the door of the Friarage.

house next door Abbot Bank was built in 1820, excavations revealed the ground floor of the convent chapel along with human bones from burials.

St Andrew's Church

It is believed that there has been a church at the location of St Andrew's Church since the twelfth century and the red sandstone tower dates from the thirteenth/fourteenth century. The tower has walls six feet thick, displays the crest of the Earl of Warwick and was probably used by the local people as a protective Pele tower in times of the border raids. The rest of the church was rebuilt in the 1720s, being designed by Nicholas Hawksmoor, a pupil of Christopher Wren, and modelled on St Andrew's in Holborn, London.

The inside of the church is a gallery design with pillars supporting the gallery, each pillar made from a single stone from a Cumbrian quarry. The stained-glass East Window is by Hardman and Powell and inserted in 1870. The window is surrounded by murals depicting

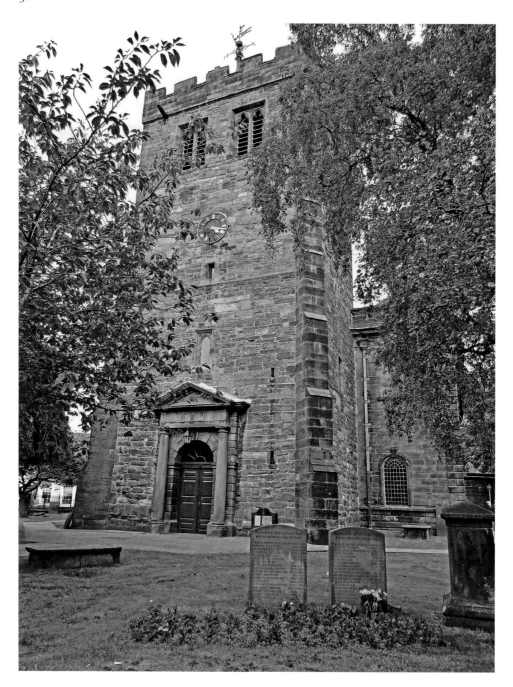

St Andrew's Church tower.

the Angel and the Shepherds, and the Agony in the Garden, both painted in 1845 by a local artist, Jacob Thompson (1806–79). The brass candelabra hanging from the roof, were a present from the Duke of Cumberland (George II's youngest son, also known as the 'Butcher of Culloden'), presented as a reward for the town's loyalty during the 1745 Jacobite uprising.

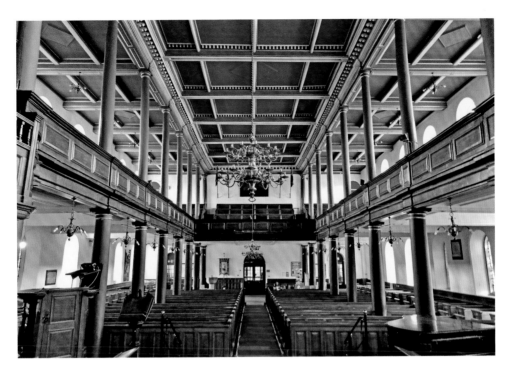

Gallery design of St Andrew's Church.

The church also contains a brass plaque to commemorate the plague victims and reads as follows

A.D. MDXCVIII Ex gravi Peste, quoe Regionibus hisce incubuit, Obierunt, Apud / PENRITH, 2260 / KENDAL, 2500 / RICHMOND, 2200 / CARLISLE, 1196 / POSTERI Averite vo, et Vivite / EZEK. XVIII.32.

In the churchyard are various items of interest, there is two 11-foot-high stone wheel crosses combining Christian and Viking carvings. These are known as the 'Giant's Grave', the Norse crosses date from tenth century and are separated by four similarly aged hogback tombstones. There is also a wheel head cross, known as the 'Giants Thumb', which is thought to have been erected by Owen, King of Cumbria, as a memorial to his father. Previously it was used as a pillory (whipping post) to punish offenders and the lower holes may have been modified to suit. Thought to be circa AD 920, the base is considerably later and was used to mount the cross in 1887. There is also a monument to the railway contractors dating from 1846. The monument is a Victorian Gothic structure commemorating the building of the Lancaster to Carlisle Railway and is very Victorian Gothic in style.

One of the most interesting burials within the graveyard is a lady called Mary Noble who died in 1823 at the age of 107. She was written about by Thomas Barnes, MD under the title *Biography of a Centenarian. Account of Mary Noble, of Penrith, in the 107th Year of her Age.* He described her as a small woman, weighing less than 5 stone and being much

One of the pair of chandeliers presented to the town by the Duke of Cumberland.

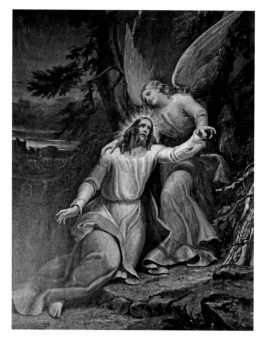

The murals painted by local artist, Jacob Thompson.

Above: In 1870 this organ
was built by T. H. Harrison of
Rochdale, replacing the old
one from 1799 and has been
repaired and renovated several
times since.

Right: The 'Giants Grave' in
St Andrew's Churchyard.

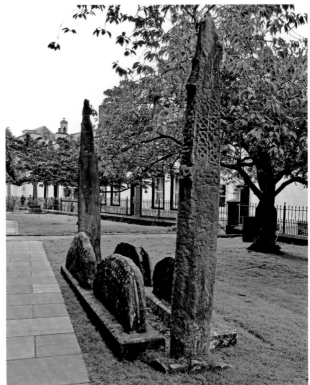

wrinkled, with clear eyes, but eyelids 'everted and affected with lippitude'. He also said she has had no teeth for twenty years, but could still chew food with her firm gums. In her 106th year she was still spinning a high-quality yarn with a spinning wheel, which was common among the poor folk of the time.

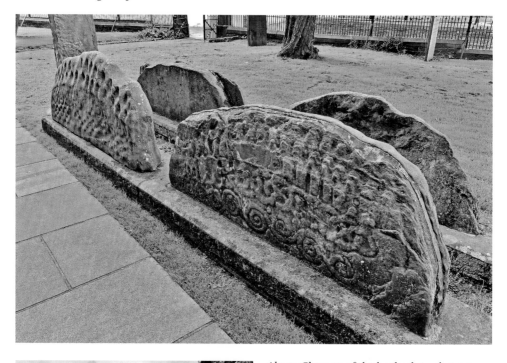

Above: Close-up of the hogback tombstones showing the detailed carving.

Left: 'Giants Thumb' wheel-head cross in the churchyard.

1846 monument to the men who built the Lancaster to Carlisle Railway.

The Gloucester Arms

The Gloucester Arms is named after the Duke of Gloucester, who is better known as Richard III, one of the most notorious kings in our history. It is named this because it is supposed to have been a home for Richard, Duke of Gloucester while the main castle of Penrith was being renovated and modified to house a brother of the King of England. Before his infamy, Richard was granted huge estates and titles in the north, and he was made high sheriff of Cumberland. He was known as a good and fair lord, as well as a good administrator and most of the bad publicity he received was instigated by the Tudor dynasty to reinforce their position of power.

The Gloucester Arms is thought to have started life as a red sandstone Pelé tower around 1470 and extensively added to in around 1580 when it became a coaching inn. Originally called Dockray Hall, there are strong local rumours and some written word, which talks about a tunnel linking the castle with a room in the hall, though this has never been proved. Above the main doorway there is a carved and painted coat of arms of de Whelpdale and the white boar of Richard III which were added later as an acknowledgment of his residence.

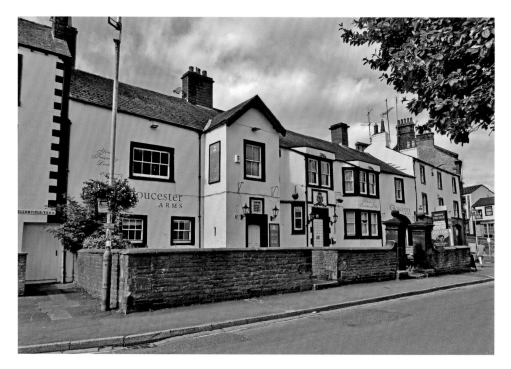

The Gloucester Arms in Great Dockray.

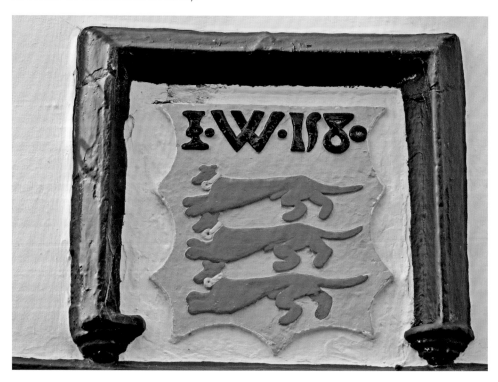

Richard III coat of arms over the main door to The Gloucester Arms.

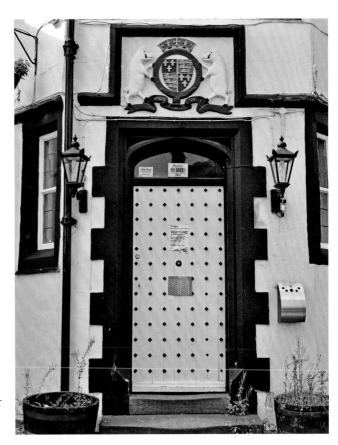

Inscription above another door
at The Gloucester Arms are of
John de Whelpdale dated 1580.

The Two Lions Inn

The Two Lions is an old public house located at the junctions of Rowcliffe Lane and Angel Lane. Though with later additions, the main building was probably built during the sixteenth century and was the home of Gerard Lowther. Lowther was the younger son of one of the most important families in the area and led a colourful life, as sheriff of Cumberland and later the lord warden of the West Marches. He was also involved with his brother, Sir Richard Lowther, in embracing the cause of Mary Queen of Scots and took a prominent role in the 'treasonable acts' of the earls of Northumberland and Westmorland. When the rebellion collapsed he fled to Scotland where he remained until he was pardoned.

It is likely that the building was erected as a fortified house circa 1585 and evidence for this is seen in the decorated ceiling with heraldic bosses bearing this date. The bedroom above has another plaster ceiling bearing the letters 'GLL' for Gerard and Lucie Lowther with the date 1586. It is also likely this was built on the site of an earlier building and heavily modified to a high status manorial building to overlook the Dockray courtyard. The building was added to and modified to suit the roles of its subsequent occupiers until it became a public house and hotel in the nineteenth century. At the head of the alley from the old public house to the new shopping area behind is an old wood and metal studded door which is clearly of some age, but it is not known how old.

Rear of the Two Lions reveals the small medieval windows, possibly of the original fortified tower.

The back of the Two Lions recently renovated as part of 'The New Squares' development.

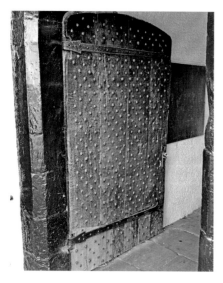

The old door of the Two Lions that leads to the 'The New Squares' development.

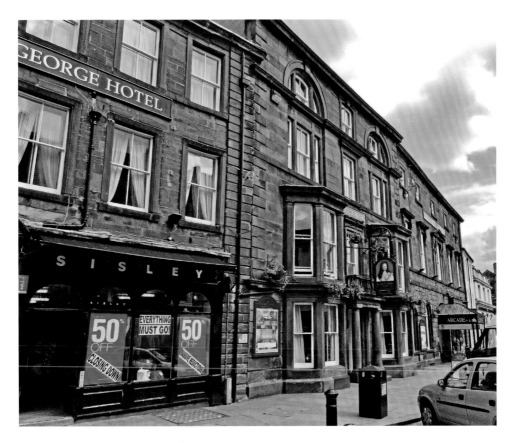

The George Hotel in the heart of the town.

The George Hotel

The George Hotel can be traced back as far as the 1500s when it was known as The George and Dragon Inn but was much changed in the late eighteenth century to become the hotel it is now. One of the most famous 'guests' was Bonnie Prince Charlie, who is reported to have lodged here around November 1745. During the Jacobite Revolution of 1745 he was travelling south on his ill-fated journey to attempt the seizure of the English crown for the Stuarts (See Section 2 for more details). There is a blue plaque on the wall to the left of the building to commemorate this event.

The Robin Hood

The Robin Hood in King Street is all part of the Wordsworth myth which is prevalent in the Lake District and may claim to have witnessed events that would ultimately lead to Wordsworth fulfilling his potential. There is a plaque to the front of the pub which reads 'William Wordsworth stayed here with Raisley Calvert 1794–45', but who was Raisley Calvert?

Raisley Calvert and his brother were sons of the steward of the Duke of Norfolk who owned property in the in the Greystoke area. They had met when at the grammar school in Hawkshead and became friends but the still young Raisley, early twenties, was found to be dying of consumption or what we now know as tuberculosis.

He was a great admirer of Wordsworth's poetic talent and promised to leave him a legacy of £500 to enable him to pursue his talent. At the very beginning of an intended tour to Portugal in 1794 Raisley fell ill and the idea was abandoned. William stayed the night at the Robin Hood in Penrith before returning home the next day. Raisley lasted three months with his friend by his side but died leaving William more than promised, some nine hundred pounds. This significant inheritance enabled William to set out on a career which otherwise would probably not have been possible.

Hutton Hall

Hutton Hall sits on the junctions of Friargate, Folly Lane and Benson Row. Though the building has been heavily modified, the oldest part is a fortified tower that is thought to date to the late 1300s. To this tower is added a seventeenth-century cottage and is followed in the eighteenth century by the largest part of the complex being a red sandstone hall. The square fortified tower is four storeys high, built of the local red sandstone, now rendered and painted, and includes several very small windows/slits. There is also evidence of a curtain wall that may have surrounded the complex and been part of its formidable defences. The tower building is thought to have been erected by William Strickland, Bishop of Carlisle, around the same time as Penrith Castle.

Hutton Hall tower with the numerous small windows.

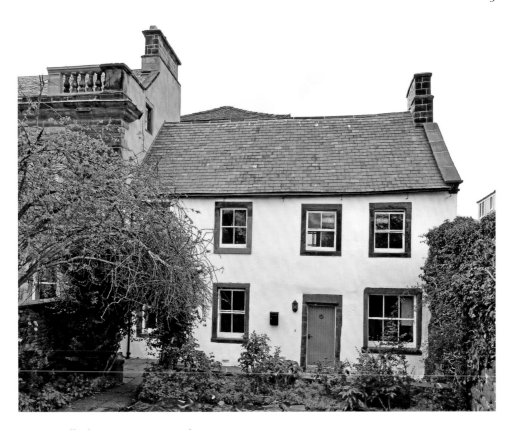

Hutton Hall adjoining a seventeenth-century cottage.

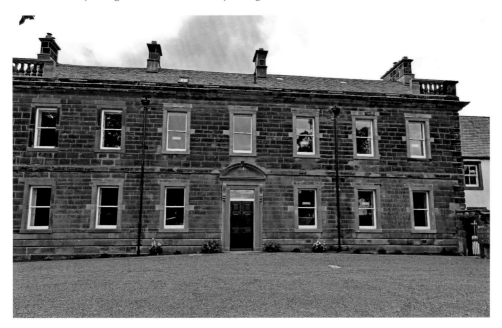

Hutton Hall, an eighteenth-century building.

Market Cross

As mentioned earlier, Penrith was granted a market charter in 1223 by Henry III and in 1854 the market rights were leased by the Board of Health until they were eventually bought outright in 1878 for £4,140. The rights to the market are now with the Eden District Council who ensures standards are met and they are promoted and publicised to the public.

As with most market towns, market day was an opportunity for the local villagers to catch up on the local news and gossip while shopping for essential supplies or selling their home produced wares. Farmers would bring their produce into Penrith on a horse and cart, and the need for stabling is seen in the many alleyways or arched access ways which lead from the front of inns to the stables behind. Farmers also used 'market day' to imbibe the local ales at one of the many public houses to catch up with local and perhaps world news.

Grain sales were held outside specific inns in the market area of the town and would be a lively affair of buying and selling. Devonshire Street was the site of The Old Shambles (a traditional name for an area of butchers in a town e.g. York, The Shambles), or the place that animals were slaughtered and butchered. Bull-baiting was a legal requirement and it was an offence to sell meat unless the bull had been baited by mastiffs first!

The ORIGINAL MARKET CROSS was located near to where the Musgrave Monument now stands and was removed during the 1807 changes to the market area. According to some sources the cross was built of wood, decorated with bears and ragged staffs, and is likely to have been the badge of the Earl of Warwick. It is also said that the building had been damaged by fire when it was used by a company of players.

The current market cross (bandstand) is situated in Great Dockray on the end of Cornmarket and was built in 1983 at the same time as some pedestrian areas were developed. The building is of a simple construction of wooden columns and beams with a tiled roof. This is in keeping with other medieval structures throughout the country where Alston nearby or Wymondham in Norfolk would be a good examples.

Map showing the old layout of the market area
No. 1 = the Wheat Market
No. 2 = the Barley Market
No. 3 = the Butchers Shambles
No. 4 = the Market Cross
No. 5 = the Beast Market
No. 6 = the Oat Market
No. 7 = the Horse Market

The current Market Cross was not built until 1983.

Castle Park

Situated next to the ancient ruins of the castle is a bowling green, some tennis courts and a children's play area. The Castle Park was laid out in 1920 but various farm buildings and a house had to be cleared to make way. A substantial wooden footbridge spans the old moat and leads to the still impressive castle ruins which are freely open to the public. At the main entrance opposite Penrith Railway Station is the Black Angel Memorial to those who died in the Boer War. This monument was moved to the park from Corney Square to its present position in 1964. The paths lead to the park which includes attractive gardens, a café and toilets, as well as a bandstand.

Moot Hall

Before you go in search of the moot hall, this building was removed circa 1807. It seems the market area was considered a collection of old fashioned, poor quality and confining buildings (see map of market area above) before an enterprise to improve the appearance of the town. The buildings called the market cross, old shambles and moot hall were demolished to create a more spacious market area, lined with shops, banks and public houses. The moot hall was situated where Arnison's drapers now stands and was used as a court, wool market, assembly space and partly as shops. The building is said to have been built 'partly of wood and partly of stone' with a tall blank wall at the back of the building, a number of shops on the west side and at the north the stairs led to the assembly hall. The building was adorned with the arms of the earl of Warwick and it is believed the moot hall dated from 1678 but was probably the site of a more ancient structure. The new

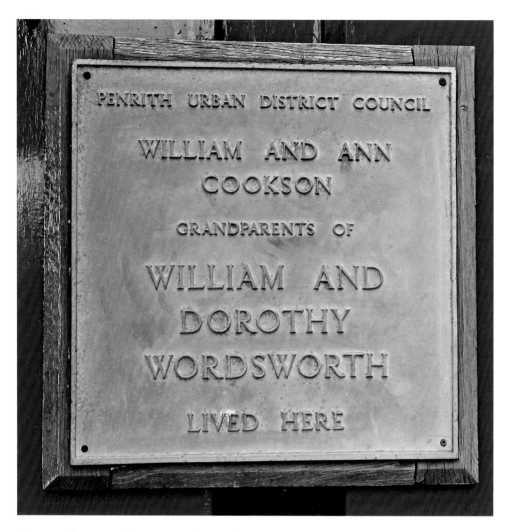

PENRITH URBAN DISTRICT COUNCIL

WILLIAM AND ANN
COOKSON

GRANDPARENTS OF

WILLIAM AND
DOROTHY
WORDSWORTH

LIVED HERE

Plaque on the corner of Arnisons to the grandparents of William Wordsworth but it actually relates to the previous structure.

building has been occupied by Arnisons the drapers since 1850. The moot hall was once owned by William Cookson, who was the grandfather of William Wordsworth and there is a plaque to commemorate this.

The Black Bull

The Board & Elbow public house was formerly known as the Black Bull and has 1624WR inscribed on lintel above a door to the left of the corn market entrance door. Originally there were grain markets held outside the inns in the corn market/Great Dockray area of town and the Black Bull was known for rye, the Black Lion for wheat, The Fish Inn and White Hart were Oats, and the Griffin was Barley. In the early 1800s the Penrith Freemasons used to meet in the Black Bull before they moved to the King of Prussia in Angel Lane and ended up acquiring Hutton Hall.

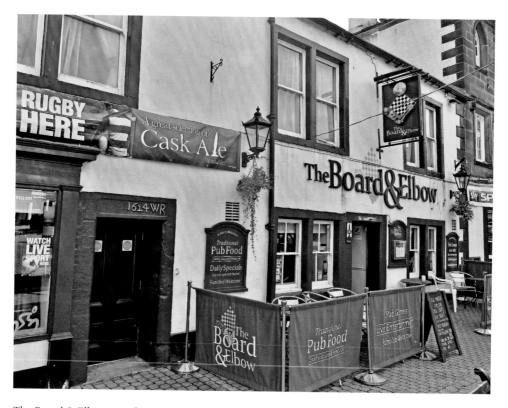

The Board & Elbow was formerly the Black Bull, one of the public houses where the grain market was held.

Lintel above the door to the Board & Elbow.

Musgrave Monument

Penrith's distinctive clock tower standing in the Market Square was erected in 1861 as a tribute from the town to Sir George and Lady Musgrave of nearby Eden Hall, in memory of their eldest son who died in Madrid. It is built on the spot formerly occupied by a building known as the Cross, which was described as a roof with four supporting pillars where eggs and butter were sold on a market day (see further information above).

Musgrave Monument stands on the site of the old Market Cross.

The monument is built of grey stone ashlar and has a square base with corner buttresses. It stands over 30 feet tall, houses a clock face on each side and is topped with a pyramidal pointed roof ending in an iron finial. The inscription reads: 'In sympathy with the great sorrow which befell the family at Eden Hall in the death of their eldest son, Philip Musgrave, Esquire, on the 16 May 1859, at Madrid in the twenty-sixth year of his age'.

The accounts from the time state that,

Mr Musgrave has, for a long time past, been in an ailing condition. When the Russian war broke out, he was compelled, much against his inclination, to leave his regiment (the 17th Lancers) at Varna and return to England, where, on seeing him, his usual medical attendant said that had he remained a short time longer in the east, he must have returned a corpse.

He must have been sent to Madrid for the dryer air in an attempt to cure him of his ailment, this was however unsuccessful, but at least he apparently died among friends.

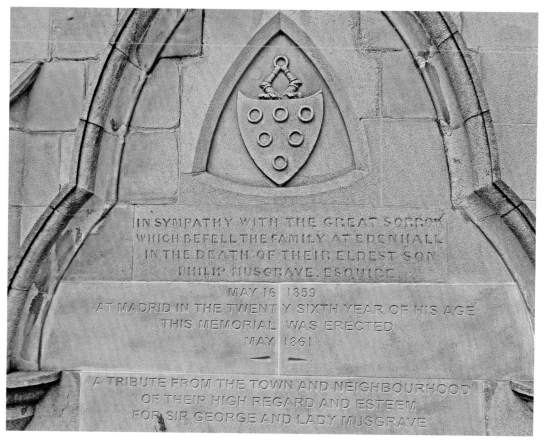

Inscription on the Musgrave Monument.

Musgrave Hall

Musgrave Hall in Middlegate is opposite the Penrith and Eden Museum and is currently occupied by the Royal British Legion. In the lintel of a former doorway are the painted and gilded arms of the Musgrave family, a prominent family whose origins are based in Westmoreland and Cumberland. The heraldic arms also include the date 1615 but most of this listed building is stated as being late eighteenth century and nineteenth century. This would suggest the building was much modified and parts of an older hall exist within its fabric.

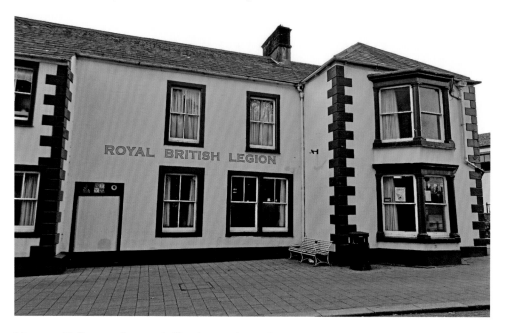

Musgrave Hall currently occupied by the Royal British Legion.

Musgrave emblems above the closed-up door of the hall.

Christ Church

Due to the increase in the population of the town during the early to mid-1800s and the need for a new burial ground to take the pressure off St Andrews, another Anglican church, Christ Church, was built 1848–50. Christ Church is an attractive building built in local red stone in the Perpendicular style, consisting of chancel, nave, aisles, south porch and an octagonal western turret. Of particular interest are the various carved heads adorning the church, the heads are of human and animal form. By 1873 further burials in the graveyard were halted and the new graveyard towards Beacon Hill was opened.

Above: Christ Church off Drovers Lane.

Right: Several detailed gargoyles adorn the church.

Prince Albert House / the Work House

Records from 1829 mention a parish workhouse on Middlegate with Mr Martindale Scott as its governor and an average number of inmates at around fifty. Are the records mistaken and referring to the building known as Prince Albert House on Albert Street?

Albert Street was formerly known as Work House Lane and is clearly indicated on Wood's Map of Penrith dated 1820. This listed building is stated as being early nineteenth century and Prince Albert was not married to Queen Victoria until 1840, so the name of the building and street must have changed after the marriage.

We do know that following the Poor Law Amendment Act of 1834, the Penrith Poor Law Union was formed by 1836. The Union had to be administered by a local Board of Guardians and Penrith contained fifty in number, representing its thirty-nine constituent parishes and townships. The Act stated that relief was only to be given to able-bodied paupers through the workhouse and central to the formation of a Union was the provision of a workhouse building. In 1838, a new workhouse was built on Greystoke Road about a mile west of the town and designed to be capable of housing 240 inmates. The union at Penrith comprised of the following parishes and townships: Ainstable and Ruckcroft, Berrier and Murrab, Bowscale, Castlesowerby, Catterlen, Croglin, Culgaith, Dacre, Edenhall, Gamblesby, Glassonby, Greystoke, Great Salkeld,

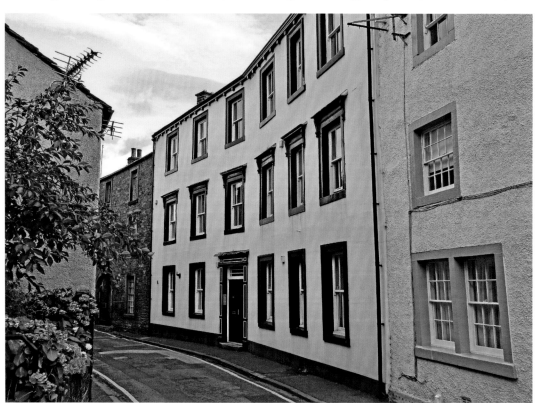

The old workhouse before it moved out of town in 1838.

Albert Street was previously known as Work House Lane.

Hesket-in-the-Forest, Hunsonby and Winskill, Hutton and Thomas Close, Hutton John, Hutton Roof, Hutton Soil, Kirkland and Blencairn, Kirkoswald, Langwathby, Lazonby, Little Salkeld, Matterdale, Melmerby, Middlesceugh, etc., Mosedale, Mungrisdale, Newton, Ousby, Penrith, Plumpton Wall, Renwick, Skelton, Skirwith, Staffield, Threlkeld, and Watermillock.

Mansion House

Mansion House was built around 1750 by John Whelpdale, a member of the prominent local family and the house remained with the family until around 1884. The building was eventually purchased by the Penrith Rural District Council in 1919 and is Grade II-listed.

Mansion House was taken over by Eden District Council which replaced the Penrith Rural District Council following the local government reorganisation in 1974. The building was in a state of dilapidation and needed a major refurbishment, and over the next few years the restoration works were carried out. The building was sympathetically restored to a very high standard and was reopened, by the Queen, in 1991.

Thacka Beck runs beneath the length of the site but is enclosed within a culvert.

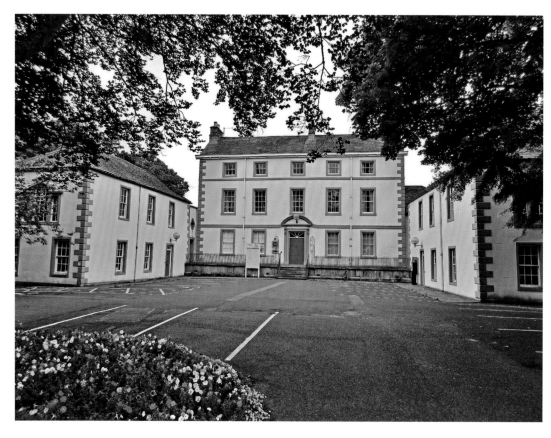

The impressive and attractively apportioned Mansion House.

Penrith Town Hall

Penrith town hall was built in 1905–06 by converting two Adam-style town houses dating from around 1791. One of the houses was occupied by John Wordsworth, who was one of William's cousins, a sea captain who worked for the East India Company and captained the same ship as Williams's younger brother, also called John. The ship named the *Earl of Abergavenny* encountered bad weather in 1805, only a short distance from the shore but unable to stop taking on water and reach the shore, John along with two thirds of the crew died. Most of the crew died from drowning or the bitter cold and John is believed to have stayed on board, drowning with his ship.

Penrith Alhambra (Lonsdale Cinema) and the Regent Cinema

The Penrith Alhambra was built by William Forrester as an entertainment hall for theatre and music in 1910 on the site of the former Middlegate Brewery. This was during the rise in popularity of the silver screen and very quickly the cinema became much more in demand. The rise in status of the screen over the stage rose even further when the first 'talkie' was shown in 1930.

Competition for the cinema going public changed in 1933 when the Regent Cinema opened on Old London Road. Very much in the art deco style, the building was designed

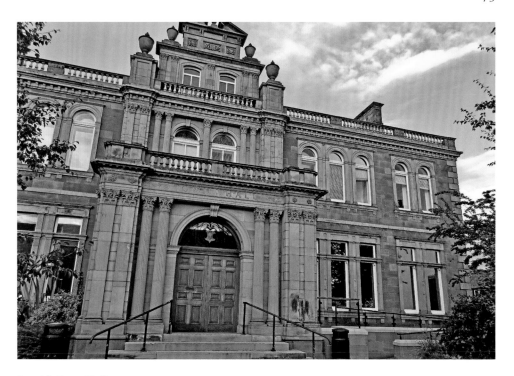

Penrith Town Hall.

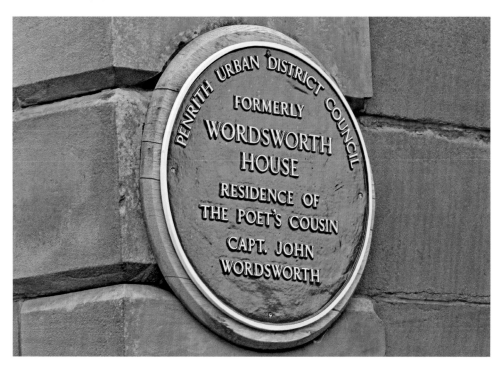

The plaque erected onto the Town Hall to commemorate William Wordsworth's cousin, John Wordsworth.

by architect G. H. Fawcett of Scarborough and was owned by New Cinema (Penrith) Ltd. The cinema had a capacity for over 700 and included a café-lounge over the entrance.

In 1971, plans were announced to change the Alhambra into a full-time bingo hall and The Regent became Penrith's sole cinema. However in 1984 the Regent Cinema closed and films returned to the sub-divided Alhambra Cinema. The Regent Cinema was then converted into a furniture showroom but has recently been converted to provide fifteen single flats for young people and includes a café.

A second cinema screen opened at the Alhambra in 1998 but over recent years there has been the threat of closure hanging over the building. After significant local campaigning and following an agreement with the owners this fantastic old music hall/cinema looks to have secured its immediate future.

DID YOU KNOW THAT!

The Lonsdale Belt, a famous boxing prize awarded to British boxing champions was introduced in 1909 by Hugh Lowther, 5th Earl of Lonsdale. He resided at Lowther Castle just south of Penrith and was renowned for his love of all sports as well as his ostentatiousness.

DID YOU KNOW THAT...?

On the north bank of the River Eamont, near Penrith, are caves known as Isis Parlis or Giants Caves. The caves are natural but have been artificially enlarged with sufficient space for over 100 people. Ancient myth tells of a giant who devoured cattle and men, though it is also said to have been used as a hermitage by St Ninian or as a place of refuge during the incursions by the Scots.

7. Thacka Beck

William Strickland, Bishop of Carlisle is credited with diverting the River Petteril to the north of the town to run to the river Eamont in the south in order to provide a water supply. This diversion is known as Thacka Beck and was installed circa 1400. Though this is argued by Bell, who states the water way is actually of Roman construction and part of a complex of canals connecting the rivers of the area together. Perhaps the Thacka Beck waterway already existed at the time of Strickland but was overgrown and damaged by floods. The word Thacka is thought to be derived from the Norse word þekja (pronounced thak-ja a word for cover/thatch with reeds). Strickland may simply have reopened and refurbished the stream for the use of the local populous. Evidence for the 'Roman Canal' is not substantiated by the archaeological evidence associated with Thacka Beck which was undertaken in 2009.

When the stream was completed in 1400, the townspeople were only allowed to draw as much water from the Petteril 'as would flow through the eye of a millstone'. This is why there is a millstone next to an exposed part of the beck adjacent the Penrith Museum on Middlegate. As mentioned previously, it is unusual for a market town like Penrith not to have grown up around a river or a castle and clearly as the town grew, the need for a fresh water supply became vital for industry and sanitation.

The 1787 map of Penrith by James Clarke shows the beck almost completely visible and though parts are shown covered in an 1820 map, it was the Victorians who built most of the brick culverts to hide the beck. The beck, almost fully exposed, is shown running relatively straight down past Townhead to Middlegate, where it turns parallel with Boroughgate before crossing at Sandgate. It then runs straight until it follows Friargate, turns 45 degrees and tracks parallel to Bridge Lane.

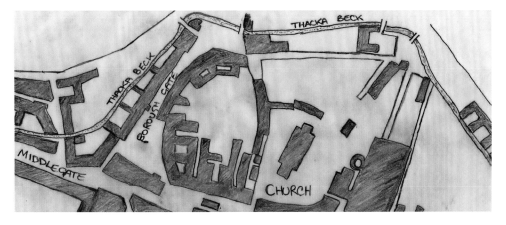

Copy of a map from 1787 showing the route of Thacka Beck is much as it is today but not culverted and still visible.

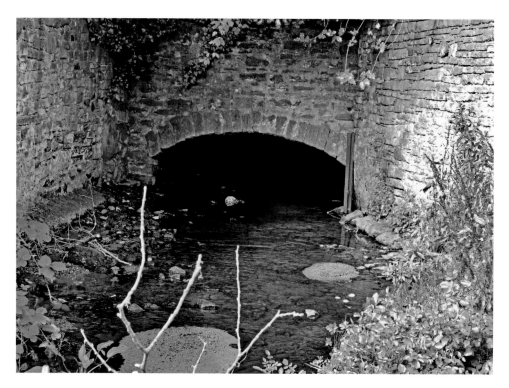

Thacka Beck as it enters Watson Terrace.

Watson Terrace Thacka Beck Trash Screen.

View of Watson Terrace where Thacka Beck runs below the surface before entering Duke Street.

The route today starts two miles north of the town from the Petteril and runs through a nature reserve before crossing under the railway towards Watson Terrace. It is at this point the beck flows into a culvert down towards Duke Street and does not reappear until Middlegate, just behind the Penrith Museum, where after a few metres disappears into a culvert again down to Brook Street.

Still underground the beck follows the rear of Boroughgate, turns down Friargate and is exposed again just after Roper Street. As it flows down to the hospital it is joined by Dog Beck from the North West and continues past the Garden Bank Wood until it eventually arrives at the A66. At this point the beck is ducted under the road, as well as the grounds of Carleton Hall until it resurfaces for a few metres before flowing into a the River Eamont.

In the mid-1800s there was a breakout of cholera in the county, though there was no outbreak in Penrith, improvements to sanitation were included in the 1848 Public Health Act. Considered the most important steps to improve public health were improved drainage and sewers, clean drinking water, the removal of refuse from streets and the appointment of a medical officer for each town. Penrith closed the shambles (butchers area), stopped burying the dead in the overcrowded St Andrew's graveyard and drew water from clean rivers. A new waterworks was built by 1854 to improve the sewage system and to pipe fresh water from the River Eamont into the town. Before the pumped system, the transport of fresh water used to be a task carried out by horse and cart. But the fact that Thacka beck was the main sewer before these changes must have made the southern end of the town less desirous to live in than the north. I would imagine the smell to be horrendous during the summer with the heat and low flow of the stream.

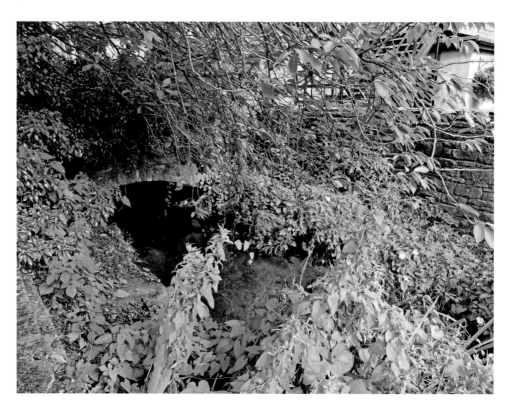

Thacka Beck reappears at the back of the space created from the Robinson schoolyard.

The beck continues past the Tourist Information centre and Penrith Museum before going underground again.

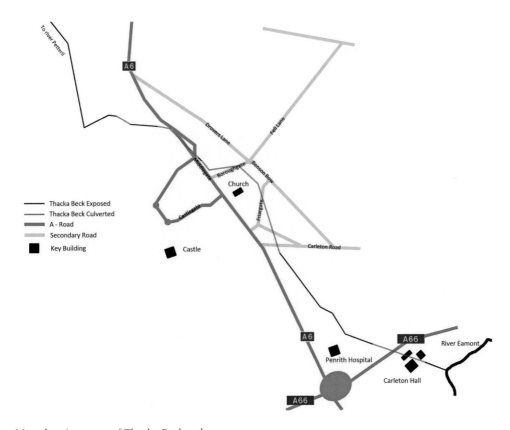

Map showing route of Thacka Beck today.

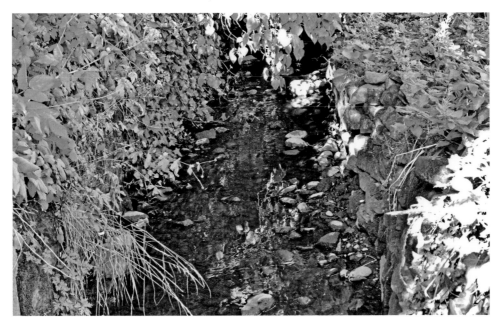

Thacka Beck re-emerging at Tynefield Court.

Tynefield Court Trash Screen.

In 1874, at a meeting of the Penrith Board of Health, Dr Robertson was confirmed as the medical officer of health and a surveyor called Todd reported 'that the repairs at the water works were now completed, and the wheel was now in full working order'. He continued, 'at present there was a good store of water in the reservoir and a constant supply to the town would now be kept up'. The Chairman responded 'that is good news, for we can now dispense with the engine and the heavy consumption of coal. It has been an expensive job, but we will get over it by paying'. A Mr Simpson stated 'I was at Eamont Bridge yesterday, and I thought the wheel worked remarkably well. It is quite a different thing to what it was before. It now 'beats time', so to speak'.

Thacka Beck was the vital artery that helped the town to live, but was also vital in its ability to grow and survive over the years. Water is the lifeblood to any conurbation, this was realised by the Romans and their management of water is renowned but the question is, was this 'artery' originally Roman, medieval or a combination of both eras?

DID YOU KNOW THAT....?

The exposed section of Thacka Beck next to the museum in Middlegate was the former Robinson's schoolyard and was transformed into an open seating area by Penrith Civic Society? It was officially opened on 13 May 1978 by Miss Shaul, the school's last headmistress. The school closed in 1971 after 300 years and later became the Penrith Museum and Tourist Information Centre.

8. Hidden Around Every Corner

Roman Gateway

On Fell Lane, opposite Brent Road, is a raised mound covered in trees and overgrown with foliage. There is a well-worn path to the top where you eventually reach a fairly flat platform about 40 metres by 26 metres (Bell). This is believed to be the Roman *vicus* (village) northern gateway and defines the northern limit of the Roman town. The 1787 map of Penrith shows Fell Lane as the only road from the town to the Beacon and is possibly built over a Roman road.

The Roman road shown on the OS Maps runs North West from Brougham Castle (Roman fort) though Carleton, the Scaws, over Fell Lane, the edge of the graveyard and on towards the A6 north of the town. Along this route it is believed there could have been some Roman occupation, as with most Roman roads small settlements would grow up to service the local fort and the soldiers within.

Steps on Fell Lane leading up to the raised Roman platform.

The slope of the platform is clearly visible as you climb the path.

The platform at the top of the slope is significantly higher than the road level below.

Plague Stone

The plague stone is located in an open park area at the end of Tynefield Drive, beside the A6 to the south of the town. What appears to be the old stone base of a cross sits on a more modern base of red stone. The stone measures about 600mm by 600mm and has a 200mm by 200mm central hollow recessed into it where the shaft of the old cross would have been located. During times of plague this hollow would be filled with vinegar into which money would be placed and any transactions carried out would avoid direct contact with potentially infected people. They must have known at the time the disinfecting properties of vinegar and its ability to clean the coins.

Penrith's plague stone is a listed historic monument and is believed to be sat in its original location. This makes sense, as it is close to the major routes of the A6 north to south and the A66 east to west. Far enough out of town to be safe from contamination but close enough to all the major links and ease of access.

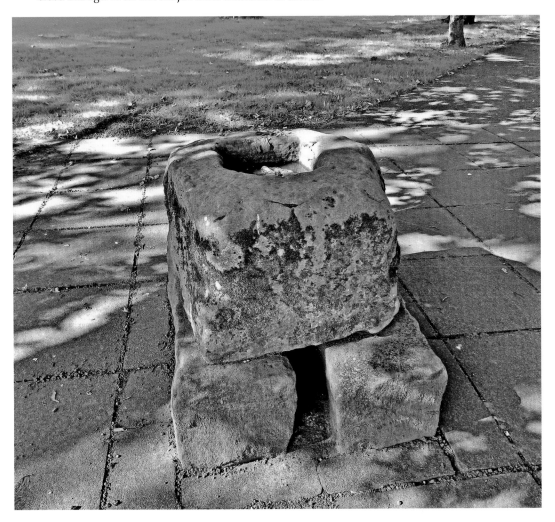

The plague stone now sits in the middle of a housing estate on Tynefield Drive.

Penrith Racecourse

To the north of the town, just off Salkeld Road is the Penrith Golf Club which used to be the site of the racecourse. It is thought horse racing took place at Penrith from the 1770s and continued until the last meeting on 28 October 1847. The principle races were the Penrith Town Plate, the Cavalry Cup and the Inglewood Hunt 5 Guineas Sweepstake. The racecourse held another purpose for a time and was used as a training ground for the Westmorland and Cumberland Yeomanry.

The racecourse was transformed to a golf course in 1890, with the clubhouse converted from the former racecourse grandstand and the 18-hole course was officially opened on 24 April 1913. The golf club was suspended during the latter stages of the First World War and the course cultivated for food production. It was not until 1922 that the course was re-instated and improvements made with the addition of a new clubhouse in 1936.

Penrith Railway Station

The station is situated on the west side of the town on the Lancaster and Carlisle Railway, just opposite the castle ruins. The building was opened on 17 December 1846 and used to be the terminus for the Railway and the North Eastern Railway's Eden Valley branch which joined with the Stainmore line at Kirkby Stephen providing connections to the East Coast Main Line at Darlington. But following the cuts as prescribed by Dr Richard Beeching, the passenger services to Kirkby Stephen and Darlington were withdrawn in 1962 following the closure of the Stainmore line, Cockermouth and Workington in 1966 and the Cockermouth, Keswick and Penrith in 1972.

Date Stones

You will have noticed from some of the photographs above, the number of date stones used on the buildings of Penrith. Below is a selection of the many more throughout the town, why not have a go trying to find them and tick them off this list.

Date stone TS 1690.

RLE 1697 and note the symbols above.

Sheep and date stone, 1776.

1660 from a cottage on Drovers Lane.

BAS or ABS 1709?

Above: 1594 in St Andrew's churchyard.

Right: Three Crowns Yard entrance.

ISM 1669.

WMF 1647 but a reused lintel; note the other stonework is newer and crisper.

1852 facing the 'New Squares' development.

DID YOU KNOW THAT…?

The 'Penrith Tea Rooms' scene in the film *Withnail and I* was actually filmed in Stony Stratford near Milton Keynes. Penrith does feature briefly, but many of the scenes are filmed in and around Shap.

About The Author

Andrew Graham Stables has had a keen interest in history since he was given a children's encyclopaedia of British history in 1971 from his grandparents. He studied History at Teesdale School Sixth Form, has a diploma in Project Management, and is a member of English Heritage as well as a regular contributor to an online local history group. He has worked in the mechanical & electrical building services industry for over thirty years and has been involved in a large number of major construction projects throughout the country. Originally from Barnard Castle, now living in York, Andrew is also working on a history of the ancient route over the Pennines known as the Stainmore Pass or the A66.

Acknowledgements

Thank you to all the people who have assisted me during the writing of this book including my wife Gillian, Gary Marshall for the permission to use photographs from the Parkin Raine Trust and Brandelhow Guest House in Penrith for a comfortable place to stay and take photographs of the town. Thank you to the publishers and their team. But special thanks to my Auntie Hannah who still lives in Penrith. This is dedicated to her and her dear departed husband Joe, who was wounded in Normandy following the D-Day invasion of northern France.

Selected Bibliography

Bell, T. C., *Penrith's Roman Heritage*, 2012

Doherty, R. *Hobart's 79th Armoured Division at War*. Barnsley: Pen & Sword Books Ltd, 2010

Finlay, M., *The Pewterers of Penrith*, 1985.

Forbes, Oliphant, Anderson and Ferrier, 1903.

Furness, W. *History of Penrith*, Carlisle, Bookcase, 1894

History, Gazetteer and Directory of Cumberland, Mannix and Whellan, 1847

Hutton Hall Bakery, Benson Row, Penrith, Cumbria: Archaeological Evaluation Report – December 2011

Jacobite Gleanings from state manuscripts

Macbeth,J., *The Transportations in 1745*

Penrith New Squares, Penrith, Cumbria: Archaeological Post-Excavation Assessment Report – October 2011

Prince Charlie's Friends or Jacobite Indictments, Edited by D. Murray Rose, Aberdeen printed for private circulation 1896

Racing Calendar, Robert J Hunter, 1824.

Short Sketches of Jacobites

Thacka Beck Flood Alleviation Scheme, Penrith, Cumbria: Archaeological Trial Trenching – October 2009

The Prisoners of the 45, edited from the state papers, Sir Bruce Gordon Seton, Br. of Ahehcokn, C.b. & Jean Gordon Arnot, printed at the University Press by T. and A. Constable Ltd for the Scottish History Society, 1929

www.geog.port.ac.uk/webmap/thelakes/html/lgaz/lk09053.htm

www.cumbriapast.com

www.british-history.ac.uk

www.visiteden.co.uk

www.qsl.net/goisw/goiswtourism.html

www.capitalpunishmentuk.org/hdq.html

www.archiver.rootsweb.ancestry.com

www.grisdalefamily.wordpress.com

www.cumbriacountyhistory.org.uk/township/penrith

www.workhouses.org.uk/Penrith/

Also available from Amberley Publishing

'This is a truly lovely little book and an invaluable companion on any walk or wander around the Lake District … It gives a fascinating and very readable background…'

Sir Chris Bonington CVO CBE DL

BETH & STEVE PIPE

HISTORIC CUMBRIA

OFF THE BEATEN TRACK

Paperback ISBN 9781445645643
eBook ISBN 9781445645728